ANTIQUES OF THE FUTURE

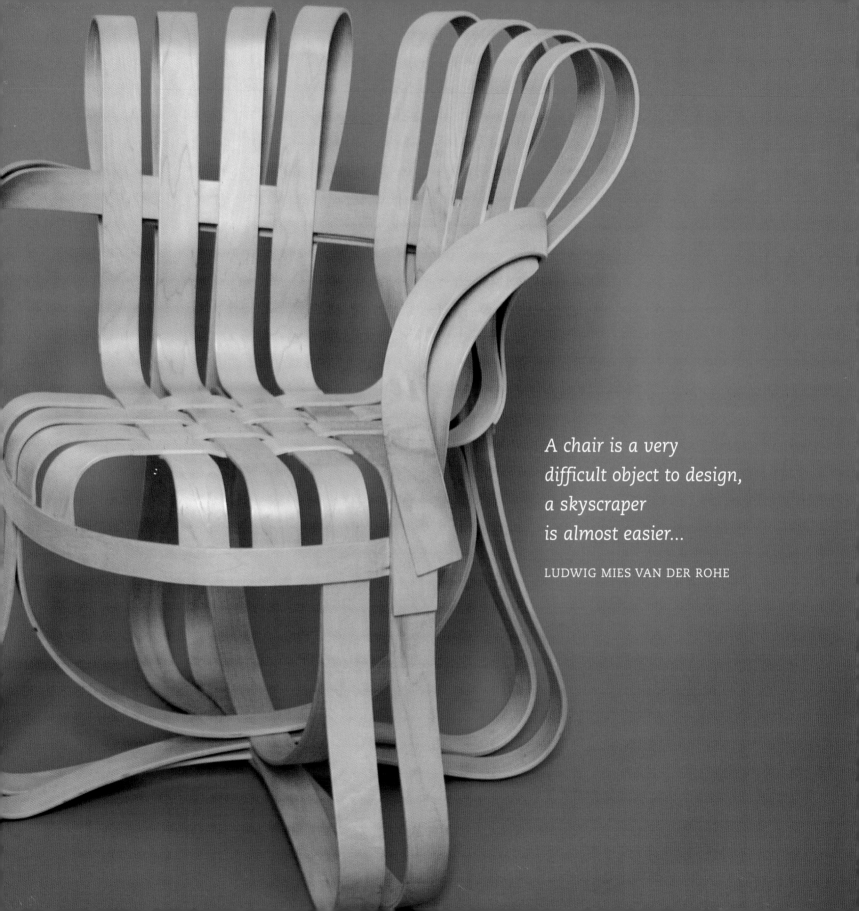

A chair is a very
difficult object to design,
a skyscraper
is almost easier...

LUDWIG MIES VAN DER ROHE

ANTIQUES OF THE FUTURE

Lisa S. Roberts

FOREWORD BY MICHAEL GRAVES

PHOTOGRAPHS BY KELLY TURSO

STEWART, TABORI & CHANG

NEW YORK

Published in 2006 by Stewart, Tabori & Chang
An imprint of Harry N. Abrams, Inc.

Library of Congress Cataloging-in-Publication Data:
Roberts, Lisa S.
Antiques of the future / Lisa S. Roberts ; foreword by
Michael Graves ; photographs by Kelly Turso.
p. cm.
Includes index.
ISBN-13: 978-1-58479-554-4
ISBN 1-58479-554-9
1. House furnishings--Collectors and collecting. I. Turso,
Kelly. II. Title.
TX311.R65 2006
790.1'32--dc22 2006006748

Designer: Lisa Benn Costigan
Editor: Kate Norment
Production Manager: Kim Tyner

The text of this book was composed in Avenir and
PMN Caecilia

Printed and bound in China
10 9 8 7 6 5 4 3 2

HNA ▮▮▮▮▮
harry n. abrams, inc.
a subsidiary of La Martinière Groupe
115 West 18th Street
New York, NY 10011
www.hnabooks.com

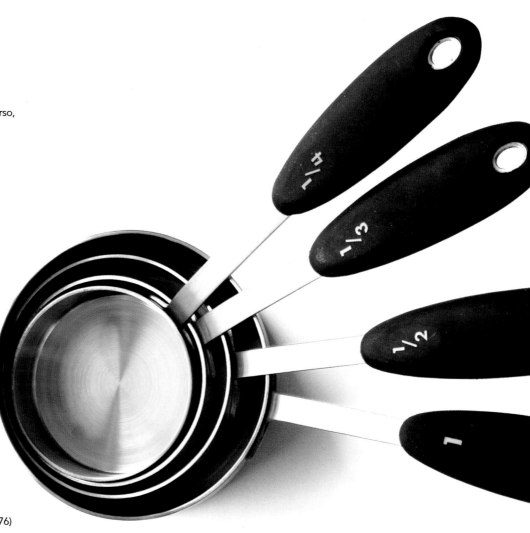

TITLE PAGE:
Frank O. Gehry's Cross Check Arm Chair (see page 176)
THIS PAGE:
Smart Design's measuring spoons for OXO (see page 68)

TABLE OFCONTENTS

FOREWORD by

A design revolution has taken place in America

over the past 25 years. It started long before that, however, with mid-20th-century designers such as Raymond Loewy, Henry Dreyfuss, and Walter Dorwin Teague, who believed that they could reshape everything, "from a lipstick to a locomotive." It's amazing to see how the convictions of a few pioneers mushroomed into a prevalent interest of the public at large. That's truly an American phenomenon.

Michael Graves

In my travels, from the time I was a student in Rome in the early 1960s to the present day, I've often remarked on the value that Europeans have traditionally placed on good design. I've seen similar attitudes in places like Japan. America may have been slow to catch on, but once good design became accessible to everyone through retailers such as Target, the rest, as they say, is history. There is no turning back. America has come to embrace and expect good design in all aspects of daily life. People today are not just aware of brands; they are also interested in the aesthetic and functional possibilities of even the most commonplace of household objects.

Lisa Roberts' book is a stylish and lighthearted look at everyday objects that, over time, will gain value as excellent examples of late 20th- and early 21st-century design. But beware. Once read and absorbed, the message is clear: You must keep every well-designed object you buy—down to the lowly toilet bowl brush—or you risk tossing out an "Antique of the Future"!

Anyone could have a museum-quality collection, if they only knew how!

This book will introduce you to a collection of award-winning designer products, many of which are found in museums, and all of which are relatively affordable and accessible.

But first, some background about the collection and the collector:

started collecting designer household products about 25 years ago. I had just changed careers from architecture to home furnishing design. And I wasn't the only one! Coincidentally, a trend was emerging in the early 1980s in which world-famous architects and industrial designers, such as Michael Graves and Philippe Starck, were asked to design all sorts of everyday objects for the home.

As part of the industry, I witnessed this explosion of extraordinary design of very ordinary objects and started collecting the ones I liked: corkscrews and vacuum cleaners, toilet brushes and tea kettles.

I knew that some of them would only be in the market for a short time since trendy designs often have limited production runs. So I jumped at the chance to get them while they were still available. At the same time, other objects caught my eye for the opposite reason. These had wide and enduring market appeal, becoming the "instant classics" of their time.

I collected more than 300 of these distinctively designed products during the next 25 years. Looking for the best designs around, I read magazines and books; consulted curators, store owners, and designers; went to exhibitions; and surfed the web.

The collection began to take on a personality. But how to describe it? It wasn't fine art, because each of the items had a practical use. It wasn't craft, since everything was mass-produced. And the term "collectible" didn't seem to do the objects justice, since many of them had won distinguished awards and were in museums.

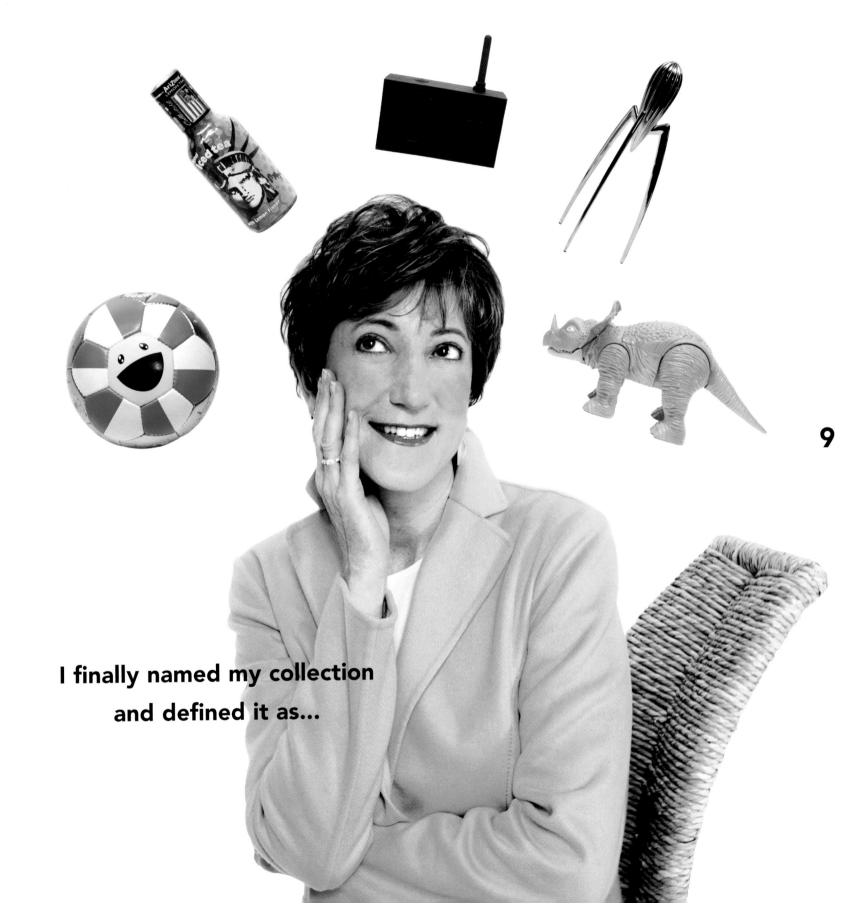

I finally named my collection
and defined it as...

9

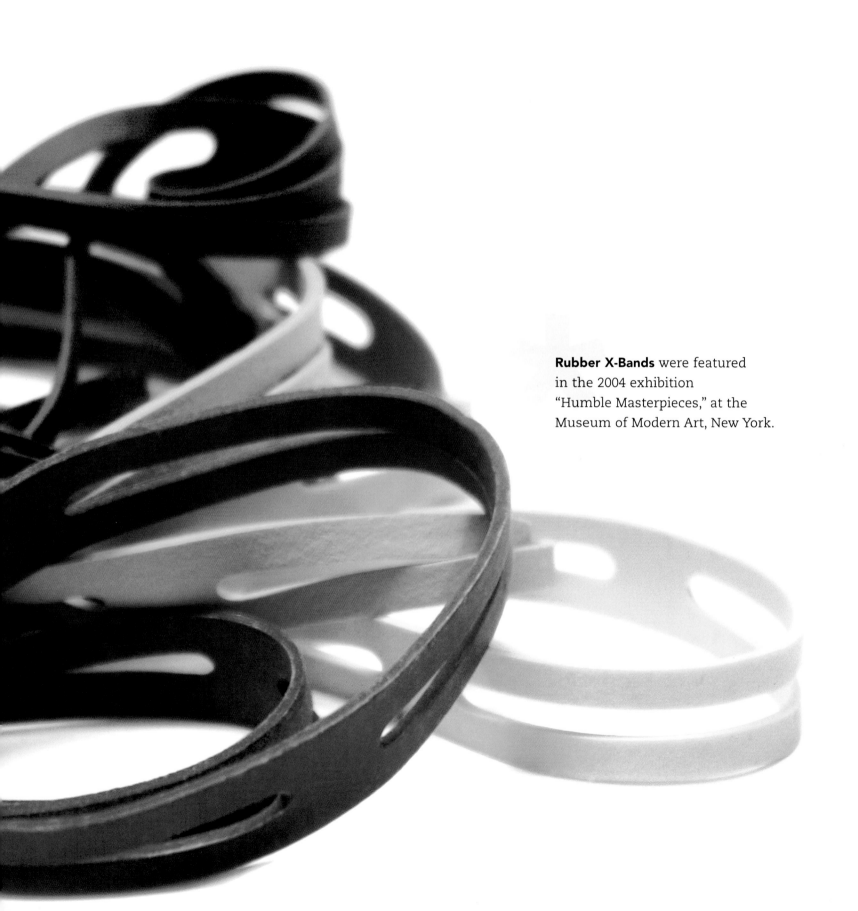

Rubber X-Bands were featured
in the 2004 exhibition
"Humble Masterpieces," at the
Museum of Modern Art, New York.

ANTIQUES
OF
THE
FUTURE

Highly designed

contemporary products that will rise in value once they are no longer in production because they represent the best of design in their time.

www.antiquesofthefuture.com

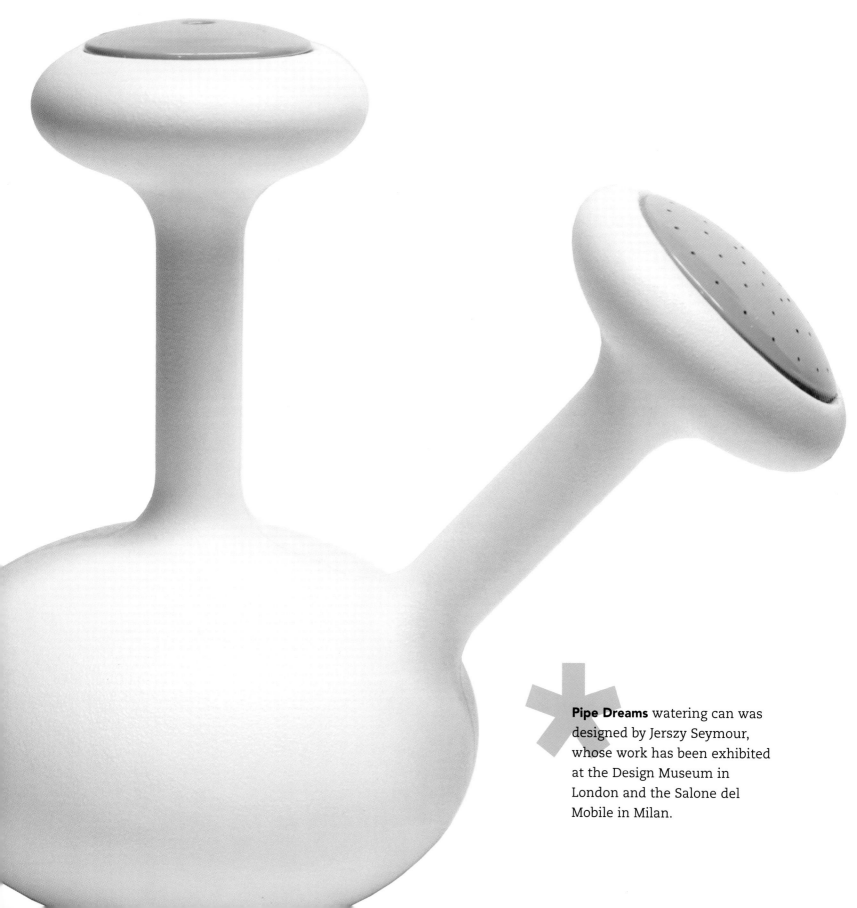

Pipe Dreams watering can was designed by Jerszy Seymour, whose work has been exhibited at the Design Museum in London and the Salone del Mobile in Milan.

To be included in my collection, an object had to have one or more of the following attributes:

Exhibited in museums or included in permanent museum collections

Designed by a notable architect or designer

Manufactured by design-oriented companies

Recipient of major design awards

Widely published in magazines or books

Since many of these objects are still being produced and sold, their future value is yet to be determined. But some of the earlier products in this collection, the ones that are no longer in production, have indeed gone up in value. See: *The Future Is Now*.

criteria

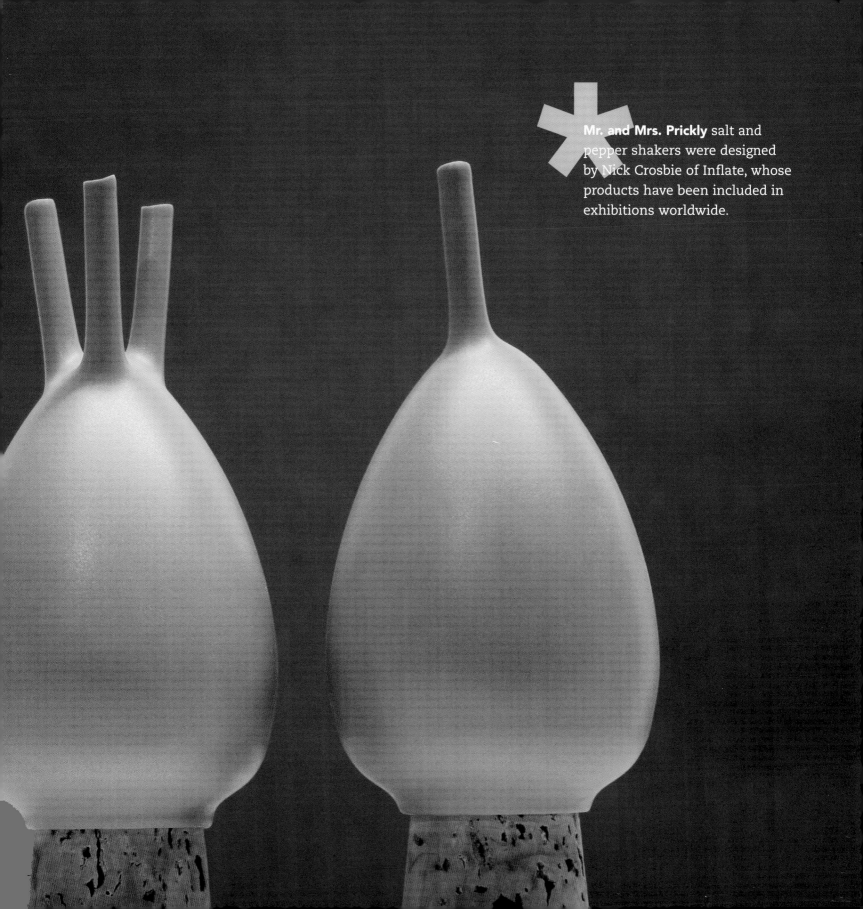

Mr. and Mrs. Prickly salt and pepper shakers were designed by Nick Crosbie of Inflate, whose products have been included in exhibitions worldwide.

About This Book

THE BOOK IS DIVIDED INTO TWO MAIN SECTIONS. The first part surveys **THE COLLECTION**. These are highlights from my collection of over 300 items. Each photograph is accompanied by an explanation as to what drew me to the product in the first place and why I wanted it in the collection. A list of statistics, including my original purchase price, accompanies each product. The second section is **RESOURCES**. This tells you where you can find these products (if they are still available) as well as other products like them. This section also lists publications, awards, and websites for researching the objects. And it provides suggestions for protecting and caring for your collection once you start to build it. Finally, I have included a sample sheet from my log book so you can keep a personal journal as you start your own **ANTIQUES OF THE FUTURE** collection.

Remember two important things as your quest begins:

buy what you like, and have fun in the process!

THE COL

LECTION

Thinking OUTSIDE The Box

Where no man, woman, or designer has gone before.

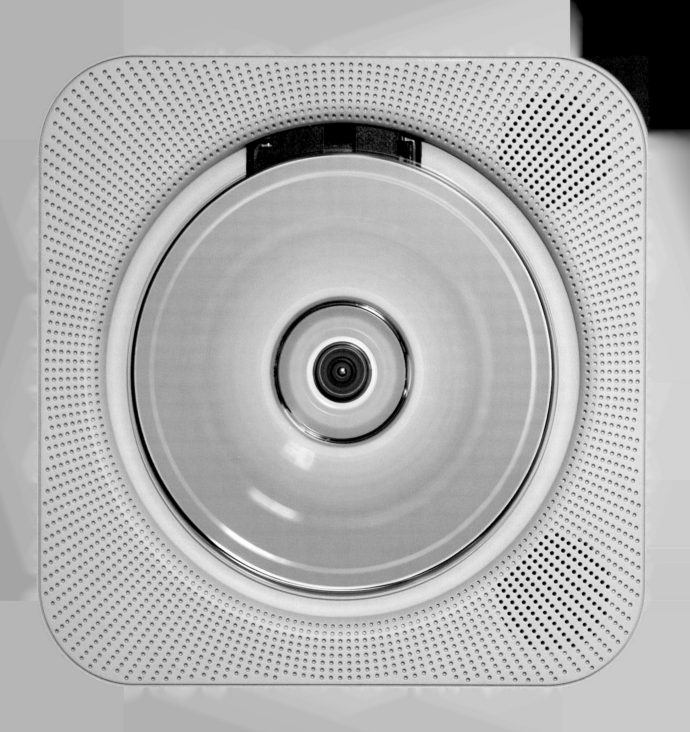

Muji CD Player

STATISTICS

Designer: Naoto Fukasawa, IDEO

Manufacturer: Muji

Date: 1999

Size: 6¾" x 6¾" x 1½"

Price I Paid: $150

The spinning discs are literally outside the box on this wall-mounted CD player—there is no cover protection. Compact in size, the unit incorporates the CD player, speaker, and controls, all in one. The cord doubles as the on/off switch and the volume and progression controls are built into the top.

For its minimalism and inventiveness, the Muji CD player has won multiple awards, been exhibited in museums, and received a lot of attention in the press.

Excalibur
Toilet Brush

Philippe Starck is one of the most recognized names in the field of design today. He has put his imprint on just about everything, from nightclubs and hotels to radios, motorcycles, telephones, juicers, and hardware. The look may vary, but the designs always show a mischievous sense of humor.

This toilet brush is a great example of his wit. He has taken the mundane and unpleasant task of toilet cleaning and given it the noble design of Excalibur, King Arthur's famous sword. Hidden in its sheath, the weapon is revealed only when ready to do battle with the toilet.

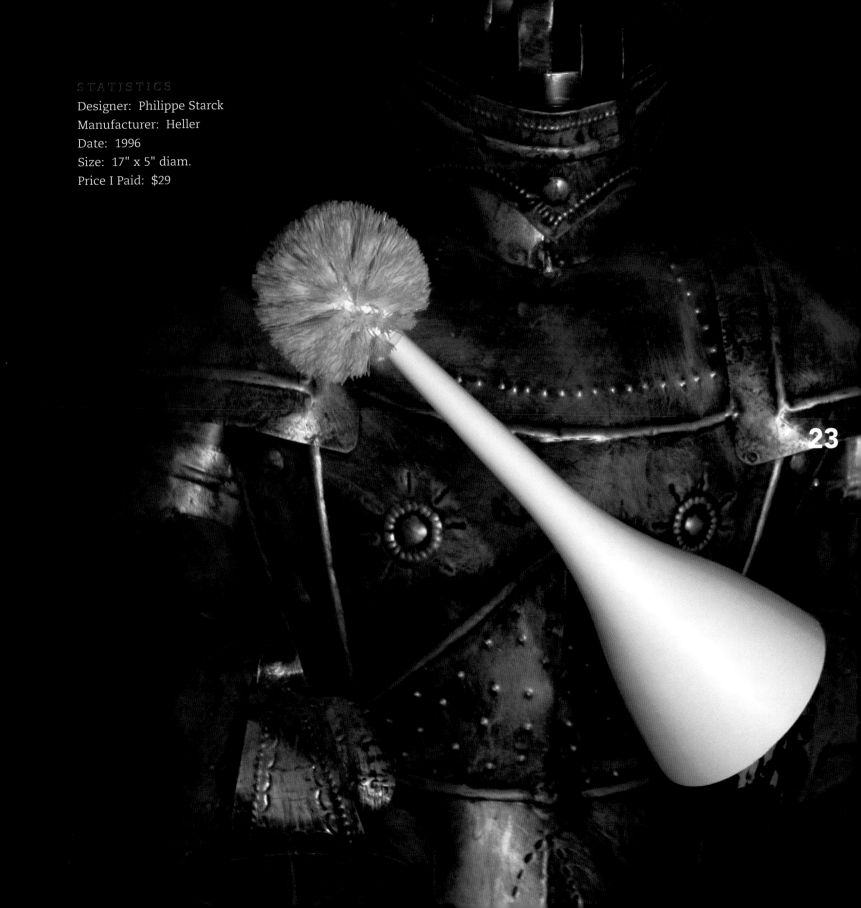

Designer: Philippe Starck
Manufacturer: Heller
Date: 1996
Size: 17" x 5" diam.
Price I Paid: $29

23

Poaa Hand Weights

Philippe Starck has designed many objects outside the traditional boundaries of his profession. In this case, he has redesigned the conventional hand weight.

Resembling a human bone, the Poaa Hand Weights have an ergonomic design. The pair includes a right-hand and a left-hand weight. Heavier on one end and asymmetrical in shape, the weights are designed to put less stress on the outer arm when lifting.

At over $400, these nickel-plated free weights will *bulge* the biceps while they *thin* the bank account.

STATISTICS
Designer: Philippe Starck
Manufacturer: XO
Date: 1999
Size: 8" x 2¾" diam.; 6½ lbs.
Price I Paid: $415

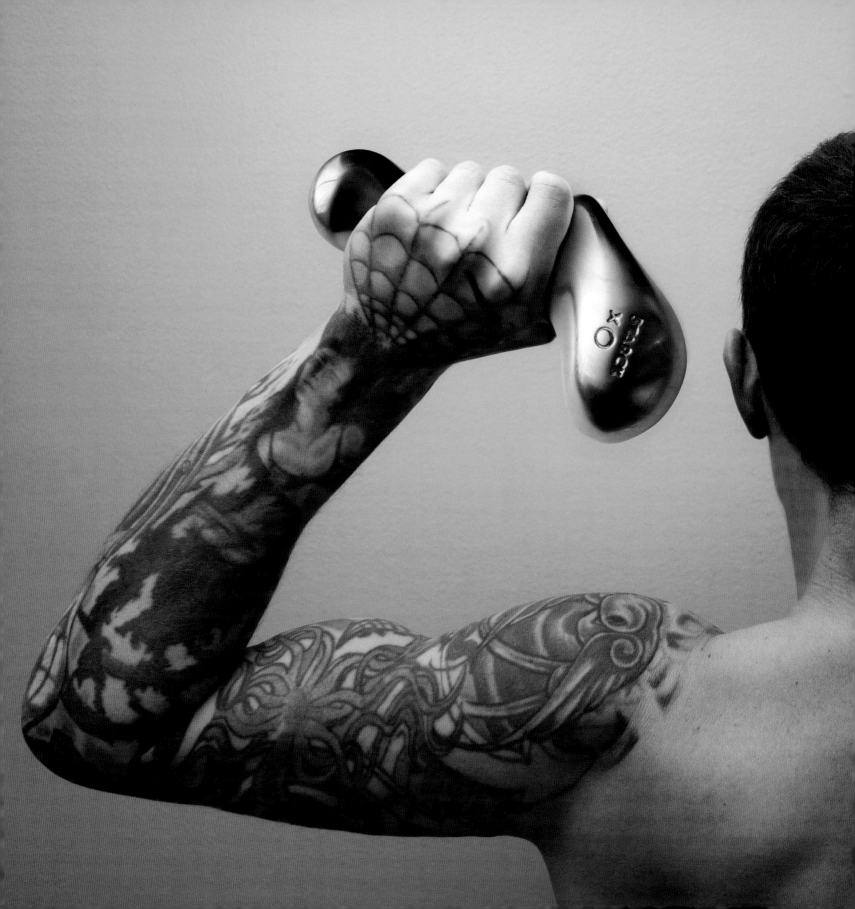

iMac G3

Trying to reclaim its position in the market, Apple totally redesigned the look of the computer in 1998. Up until that time, computers were purely functional putty-colored machines that were relegated to the back room. With its revolutionary design, the iMac clearly changed the computer industry forever.

THIS RADICAL DESIGN WAS ANYTHING BUT P.C.

Colorful, translucent, and curvilinear, this computer had style, enlivening reception desks and front counters everywhere. It came in the tutti-frutti colors of **blueberry, strawberry, grape,** tangerine, and lime, and people chose colors to reflect their personalities. And after the enormous success of the iMac, its family grew with the iBook, the iPod, and the ubiquitous iPod mini.

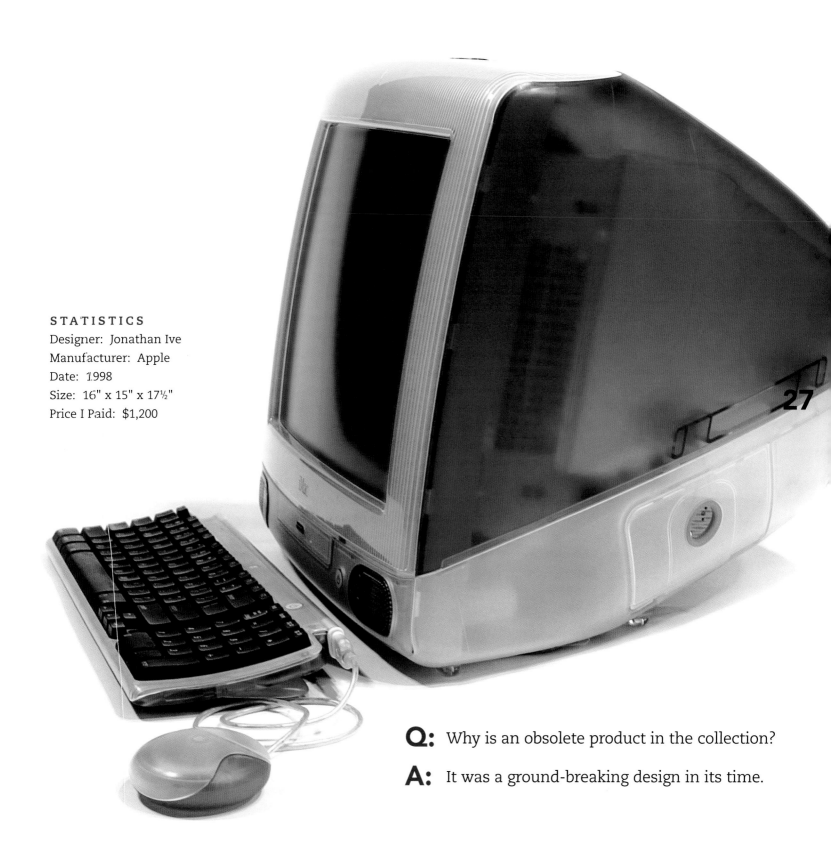

STATISTICS
Designer: Jonathan Ive
Manufacturer: Apple
Date: 1998
Size: 16" x 15" x 17½"
Price I Paid: $1,200

Q: Why is an obsolete product in the collection?

A: It was a ground-breaking design in its time.

Cable Turtle

The race between the turtle and the hare has come down to the wire!

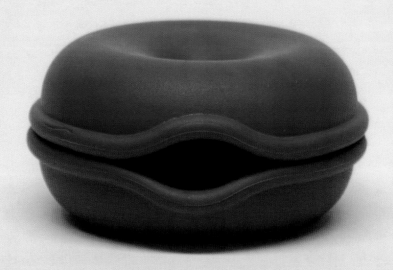

The Cable Turtle is one of the first accessories designed to address a wire-management problem created by the amount of equipment we have in our offices and homes. The concept is quite simple: the flexible shells peel back, the wires wrap around the center, and then the shells close back up to conceal the mess.

Winner of the 2002 Good Design Award (Japan) and exhibited in the Museum of Modern Art's 2004 show "Humble Masterpieces"

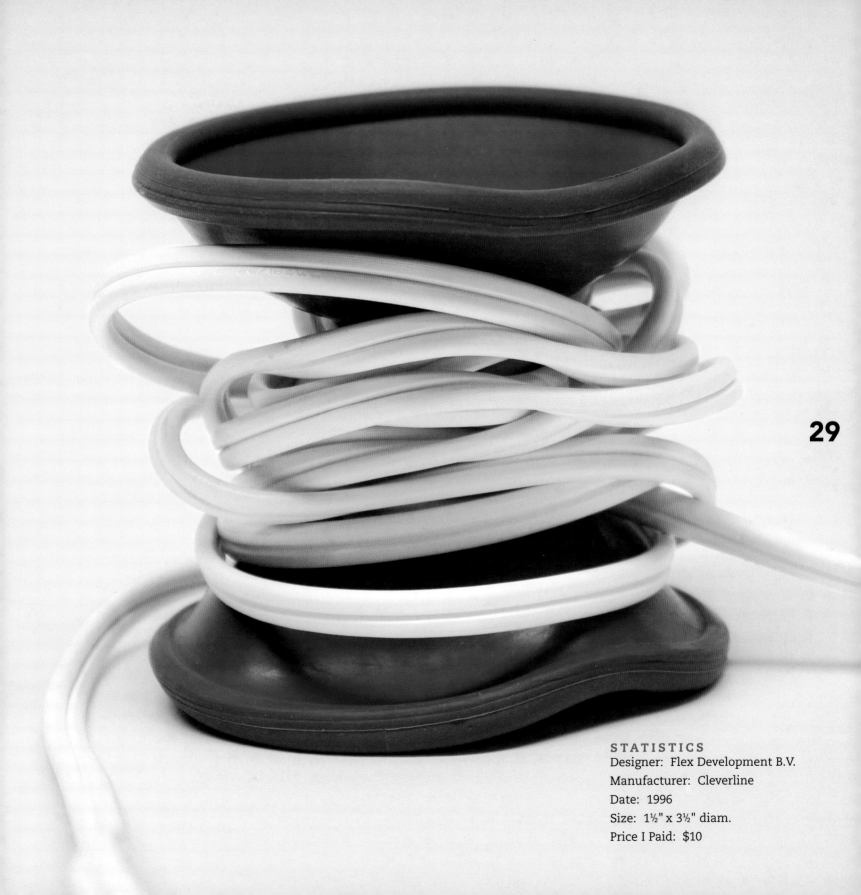

STATISTICS
Designer: Flex Development B.V.
Manufacturer: Cleverline
Date: 1996
Size: 1½" x 3½" diam.
Price I Paid: $10

RayTRAY

Sandy Chilewich co-founded HUE, the women's fashion hosiery company, where she combined Lycra with natural fibers for a new style of legwear. After great success, she sold the company and opened a design studio whose focus was making products out of non-traditional materials.

The RayBowls were her first designs, made with the same stretch fabric used for pantyhose and girdles. This strong, pliant material was wrapped around a metal frame that stretched when objects were placed inside.

They were a huge success! The RayBowls and the three-tiered set, RayTRAY, won the Best New Design Award at the 1998 New York International Gift Fair and an award from the Industrial Designers Society of America in 1999.

I am passionate about taking material out of its comfortable and predictable context. The textile that I used for all of these bowls and trays is power mesh, which is normally used for girdles.

Sandy Chilewich

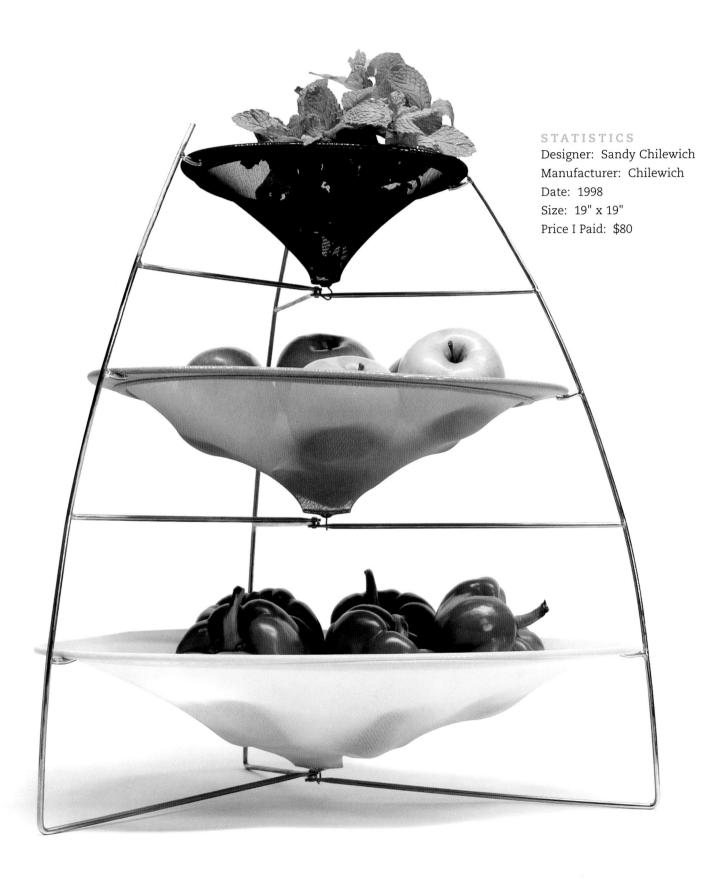

STATISTICS
Designer: Sandy Chilewich
Manufacturer: Chilewich
Date: 1998
Size: 19" x 19"
Price I Paid: $80

31

Simple
&Elegant

Simple shape. Elegant design.

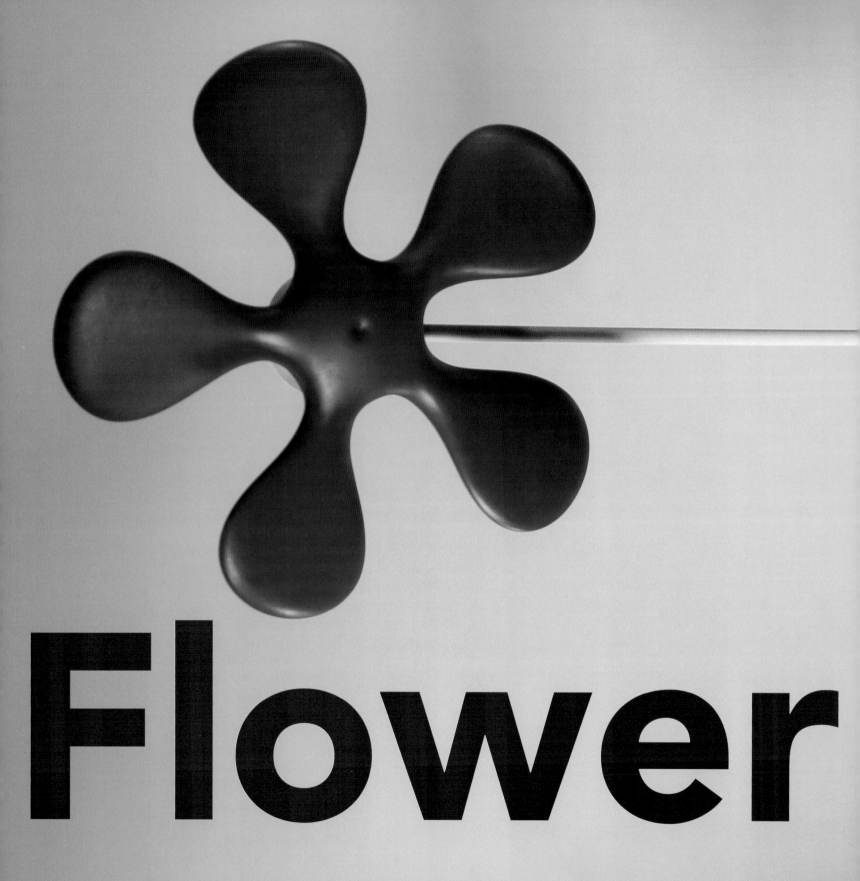

Flower

Power

NOT your typical floor fan. The long stem and cartoonish blue flower seem more like Pop Art than a conventional wind-blower. But in addition to looking good, it also works very well. Flower Power has three speeds, a silent motor, and effective wind distribution. Its most striking feature is the open blade design. You can stop the fan by putting a hand right into the middle of the spinning propeller—made out of a foam material—and not worry about losing any fingers!

STATISTICS

Designer: Zetsche + Heckhausen
Manufacturer: elmarflötotto
Date: 2002
Size: 54" x 17½" diam
Price I Paid: $399

Razor and Travel Box

Bearing no resemblance to the basic disposable razor, this small elegant shaver looks more like a piece of art. Its sculptural shape fits comfortably in the hand and the blades are easy to change. It comes with its own plastic travel box and tucks discreetly into a pocket…for those unexpected overnights.

STATISTICS
Designer: Flemming Bo Hansen
Manufacturer: Rosendahl
Date: 1988
Size: 1¾" x 1½"
Price I Paid: $29

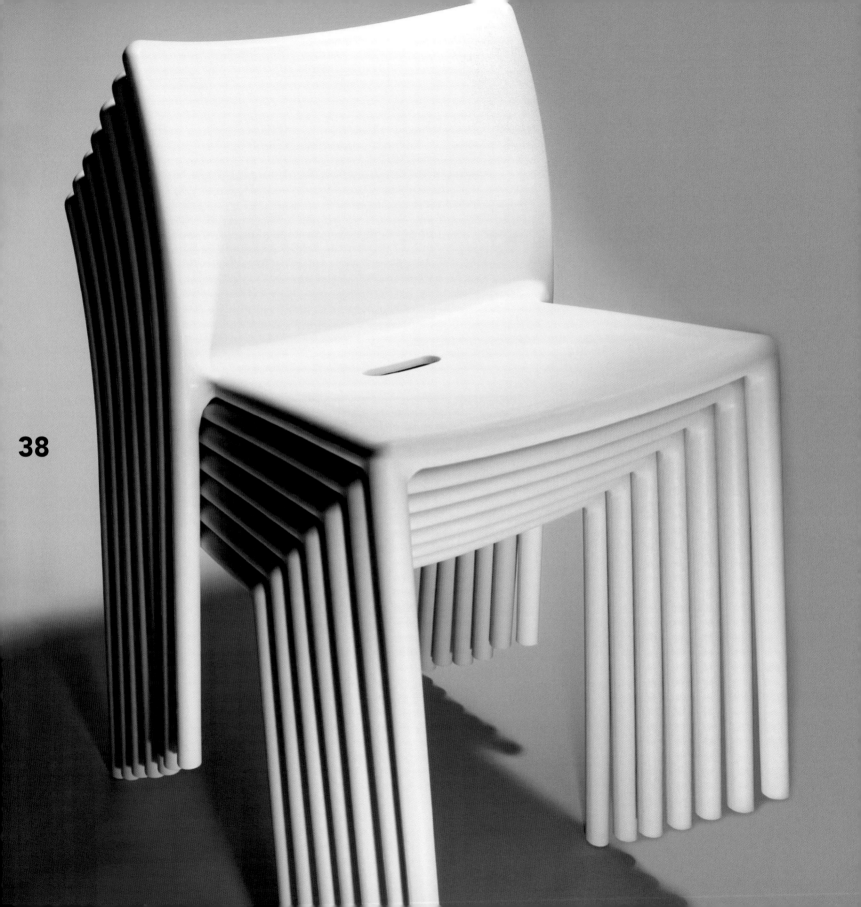

38

Air-Chair

Don't be fooled by the simplicity of this modest chair.

It is filled with air, making it relatively lightweight.

And yet, the plastic material is reinforced with fiberglass so the

chair is strong, durable, and waterproof.

The little slot in the rear doubles as a carrying handle or

a drainage hole…in case the chair is left out in the rain.

One of the world's leading industrial designers, Jasper Morrison

has been in many exhibits worldwide and won numerous awards,

including multiple Creator of the Year and Designer of the Year awards.

STATISTICS
Designer: Jasper Morrison
Manufacturer: Magis
Date: 1999
Size: 20" x 30½"
Price I Paid: $77

Kissing

Salt and Pepper Shakers

Brancusi's famous sculpture *Kiss* can be found in a museum—
so can the *Kissing Salt and Pepper Shakers*.

No matter how mundane the product, if it is exquisitely designed, it will be recognized. This is definitely true for these shakers. Together or apart, they are equally stylish. The flattened planes at the top and bottom make it easy to pass them together, and the number of holes on the top make it easy to tell them apart. The polished material looks like sterling silver but is actually a metal alloy that never tarnishes.

For all of these reasons, these kissing shakers have garnered a lot of attention. They are in the permanent collections of New York's Museum of Modern Art and the San Francisco Museum of Modern Art. They have won several major design awards and were featured in *Time* magazine (March 20, 2000).

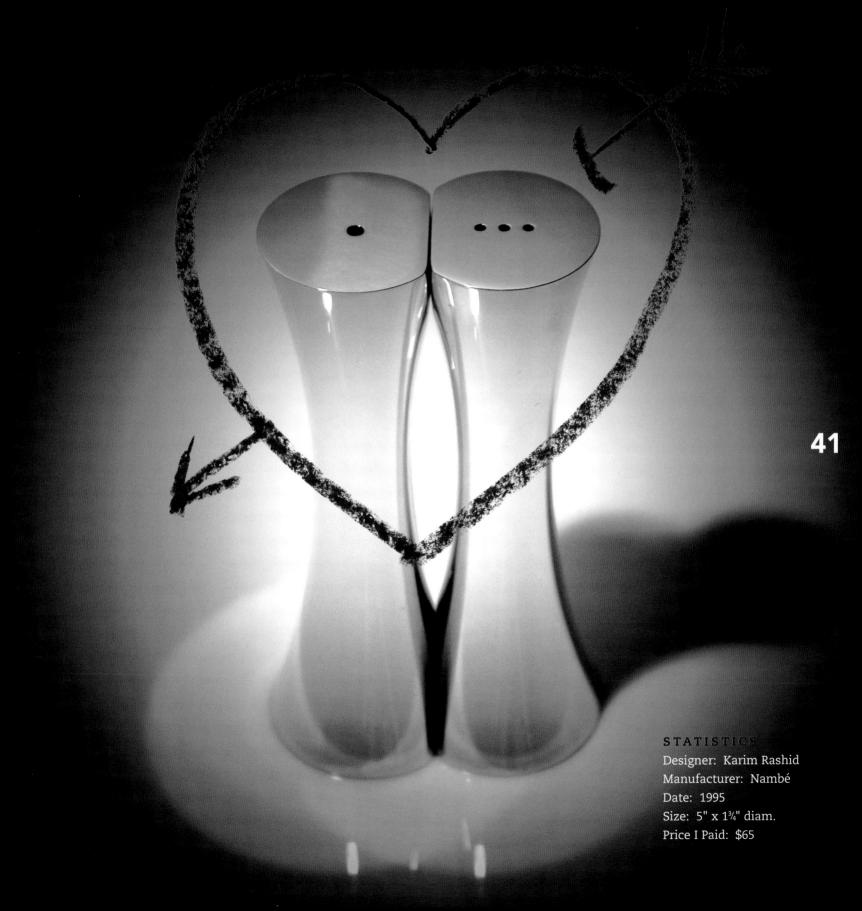

STATISTICS
Designer: Karim Rashid
Manufacturer: Nambé
Date: 1995
Size: 5" x 1¾" diam.
Price I Paid: $65

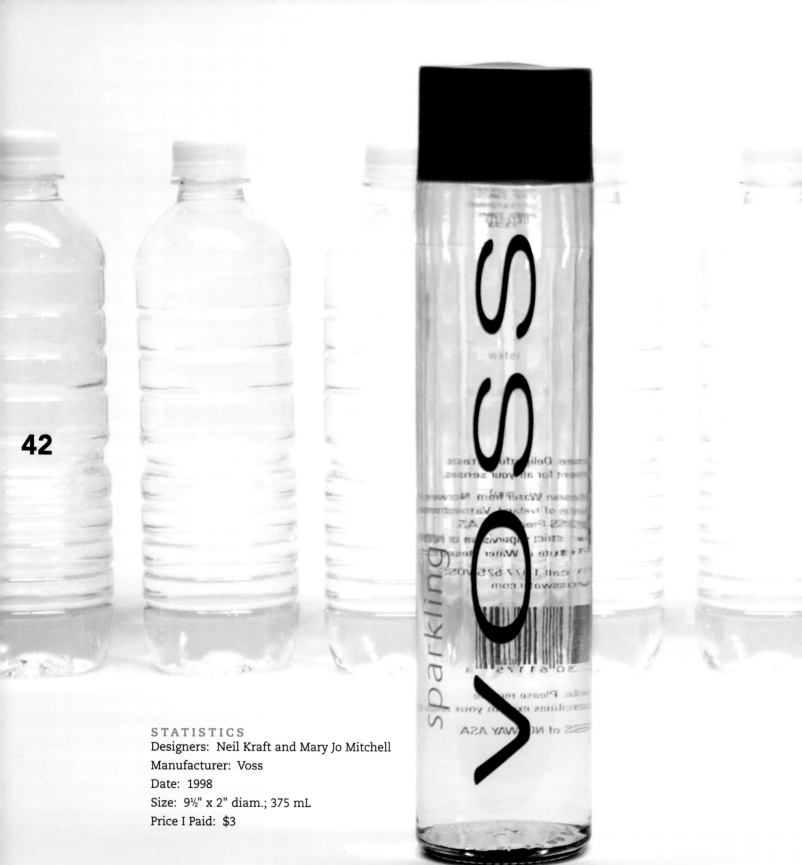

42

STATISTICS
Designers: Neil Kraft and Mary Jo Mitchell
Manufacturer: Voss
Date: 1998
Size: 9½" x 2" diam.; 375 mL
Price I Paid: $3

VOSS Water

This artesian water has been rated the highest in quality, but it is the bottle design that has won it widespread acclaim. Its sleek and modern shape is completely cylindrical. There is no tapering at the top, like most other bottles, and the spout is cleverly hidden within the silver cap.

43

{ A favorite of fine restaurants, the bottle is frequently left on the tabletop as a sign of good taste. }

Garbo

It may look like a simple trash can but it has a definite resemblance to the buxom form of a woman's torso.

The elegant shape, practical cut-out handles, and low price tag ($12) made this basket a phenomenal success. It sold an unprecedented two million pieces in its seven years of production, and it put the designer's name, Karim Rashid, on the map.

The Garbo can went on to win the Vittu 11 National Design Award in 1998 and was selected for the permanent collection of the San Francisco Museum of Modern Art. It was so widely published in design and lifestyle magazines that it became an icon of design in its time.

Today, the original **Garbo** can is no longer in production, but you can still purchase **Garbino**, a smaller version of the same can.

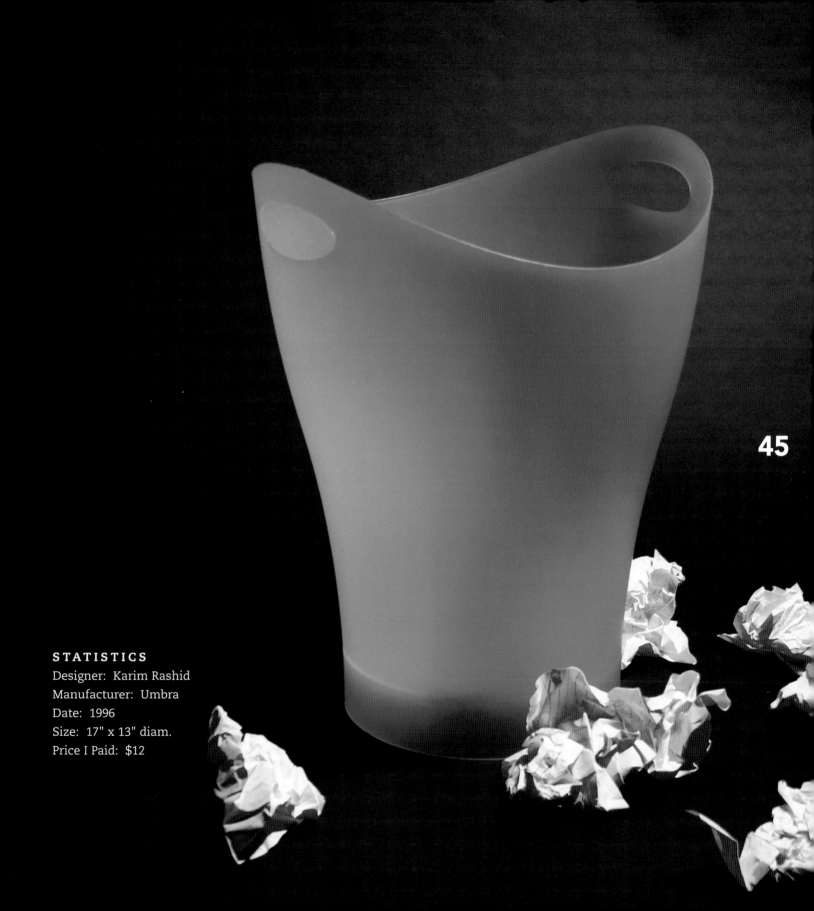

45

STATISTICS
Designer: Karim Rashid
Manufacturer: Umbra
Date: 1996
Size: 17" x 13" diam.
Price I Paid: $12

it's what?

designs that keep you guessing

Mr. and Mrs. Prickly

They look like aliens or prickly pear cacti, but they definitely don't resemble ordinary salt and pepper shakers. That's the fun of this "couple" and why they continually command attention: people can't figure out what they are! How they are made is a mystery as well. Looking like inflated balloons, the forms are created with dip-molded PVC, a form of rubber.

The manufacturer, Inflate, has won awards for both its innovative inflatable and inflatable-like products, but it is these shakers that have garnered the most attention. Seeing them on a table causes you to stop, wonder, smile...then shake.

STATISTICS
Designer: Nick Crosbie
Manufacturer: Inflate
Date: 1997
Size: 4" x 1½" diam.
Price I Paid: $18

49

Mister Meumeu

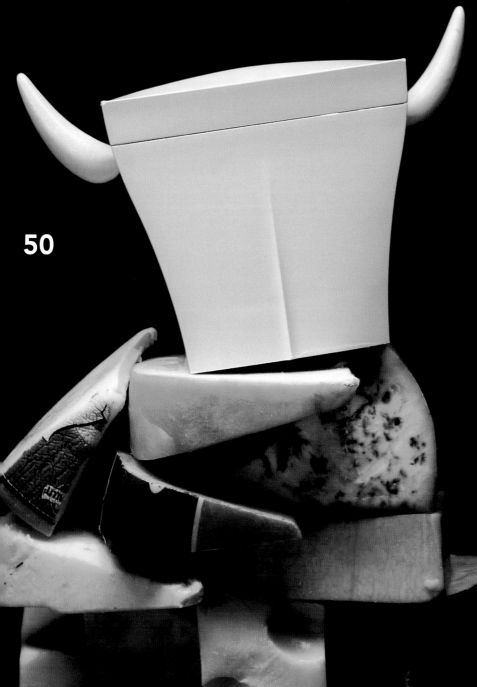

There are many levels to Mister Meumeu. On the one hand, this is a cleverly designed cheese cellar. It has a removable grater in the lid, and one of the horns serves as a spoon. But there is also a subtle irony in its references: is this a cow or a bull? Cows give milk that is turned into cheese and they moo, while bulls have horns and are "misters." This amusing gender ambiguity combined with its practical and innovative design distinguishes this product, making it a noteworthy addition to the collection.

STATISTICS
Designer: Philippe Starck
Manufacturer: Alessi
Date: 1992
Size: 8" x 3¼" x 5¼"
Price I Paid: $85

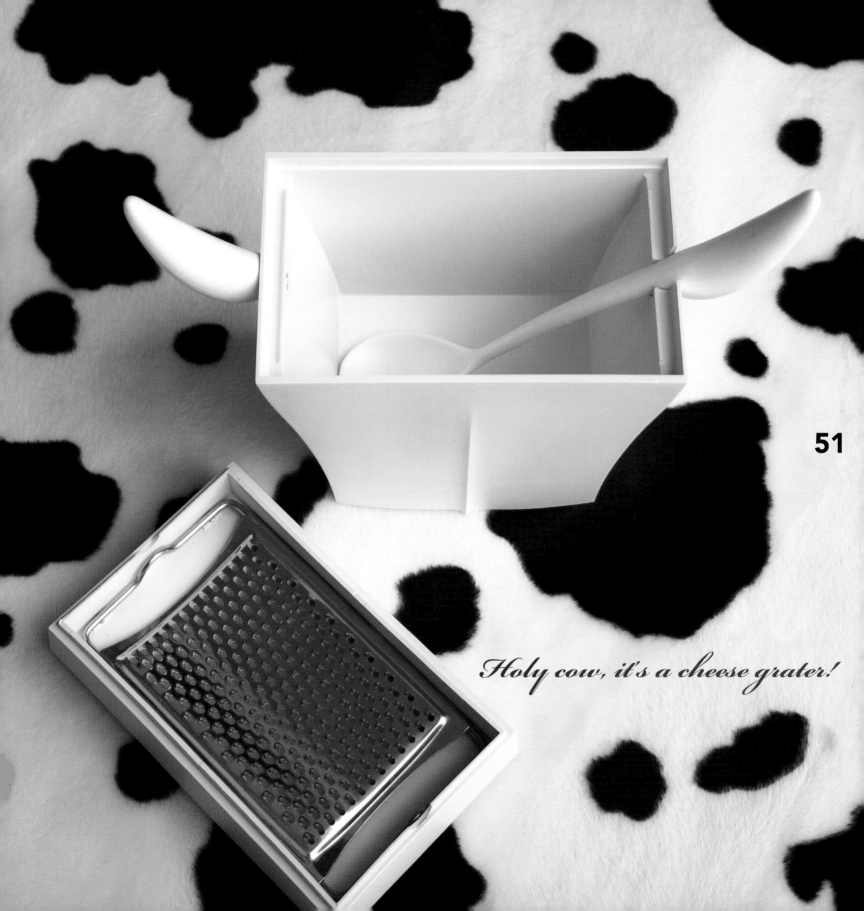

51

Holy cow, it's a cheese grater!

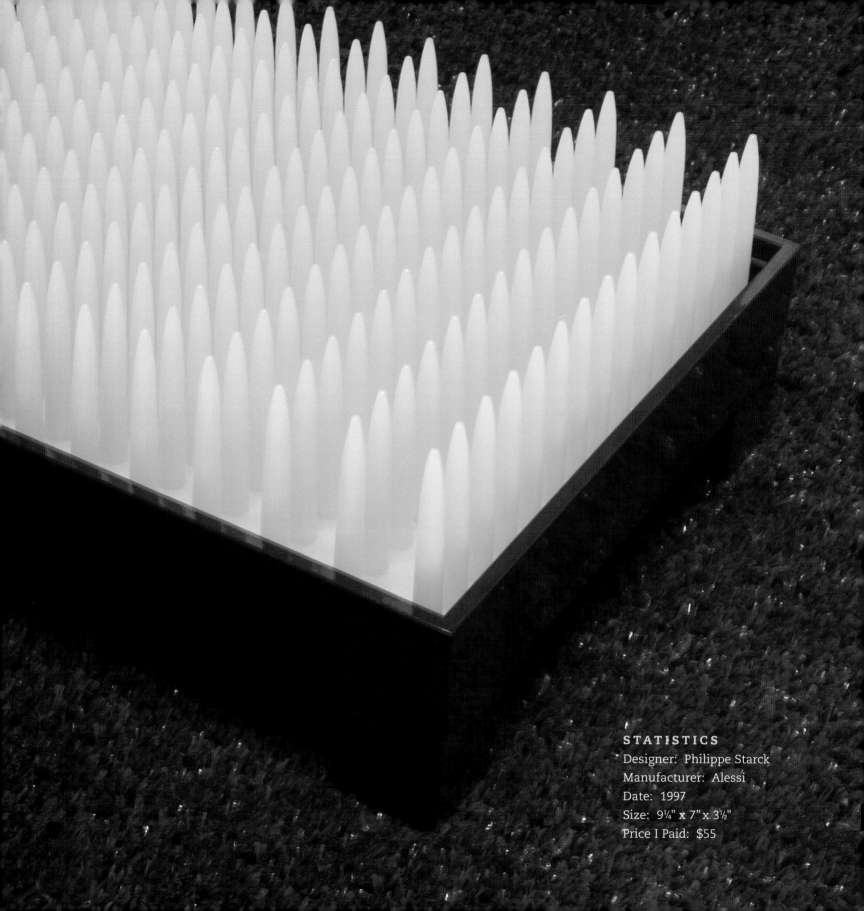

STATISTICS

Designer: Philippe Starck

Manufacturer: Alessi

Date: 1997

Size: 9¼" x 7" x 3½"

Price I Paid: $55

Liberté

There is no obvious connection between stylized grass and a letter holder. Perhaps that is why Liberté is so captivating. Its rigid vertical blades actually hold letters quite well, making it perfectly functional as a desk accessory. It is the Starck inventiveness of this design, with its absurd lawn-like reference, that gives a new twist to an otherwise common desktop item.

53

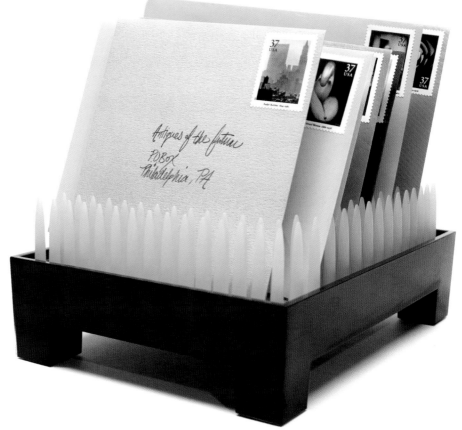

Pipe Dreams

Pipe Dreams is one of the most bizarre-looking pieces in the collection. It is completely baffling when you first look at it but makes perfect sense once you know its purpose. This easy-to-hold watering can has two different spouts, one for pouring and one for spraying. The designer, Jerszy Seymour, is known for his offbeat humor and innovative use of materials. His work has been featured in several design exhibitions, most notably at the Design Museum in London and the Salone del Mobile in Milan.

STATISTICS
Designer: Jerszy Seymour
Manufacturer: Magis
Date: 1999
Size: 11½" x 7" x 10½"
Price I Paid: $69

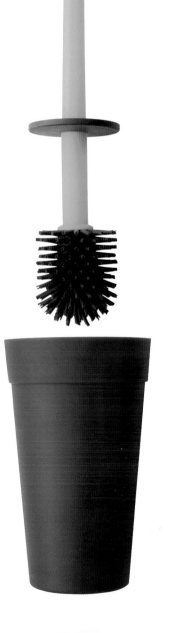

*Merdolino is an Italian
play on words meaning 'poop brush'*

(polite version)

Toilet brush design has become an unusual obsession for many designers. This example resembles a strange-looking potted plant that makes no reference to its real function. Once the "plant" is pulled from the pot, its purpose becomes quite clear.

Merdolino's creator, Stefano Giovannoni, is a renowned architect and industrial designer whose tongue-in-cheek designs have won many awards.

STATISTICS
Designer: Stefano Giovannoni
Manufacturer: Alessi
Date: 1993
Size: 19" x 4¾" diam.
Price I Paid: $56

56

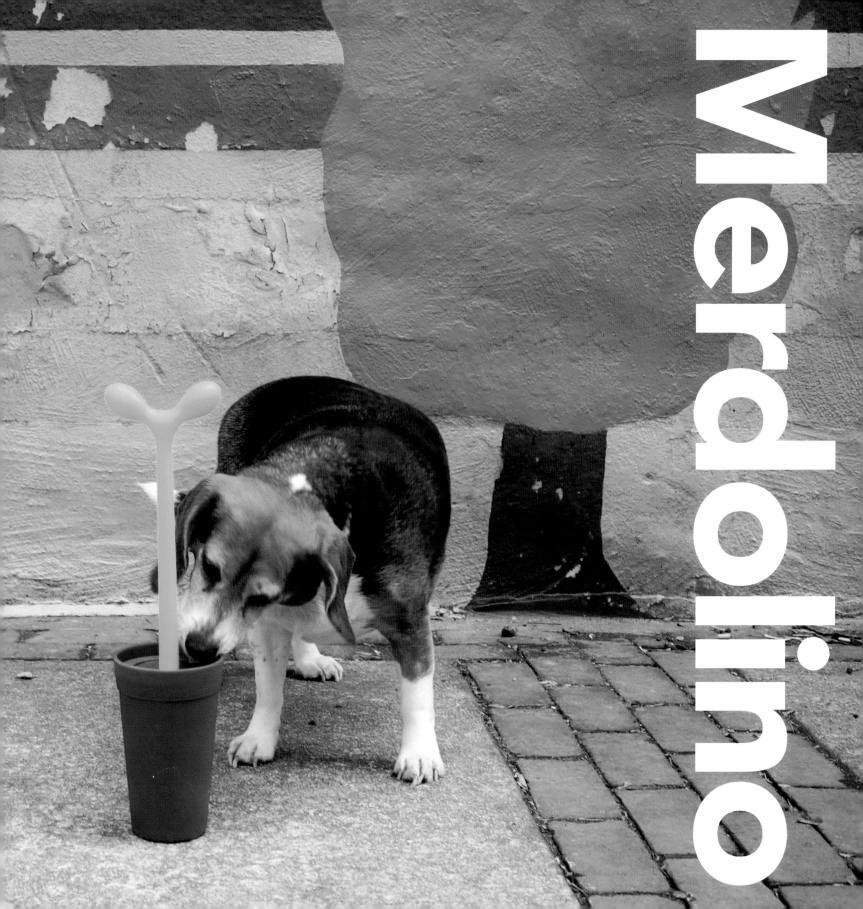

Merdolino

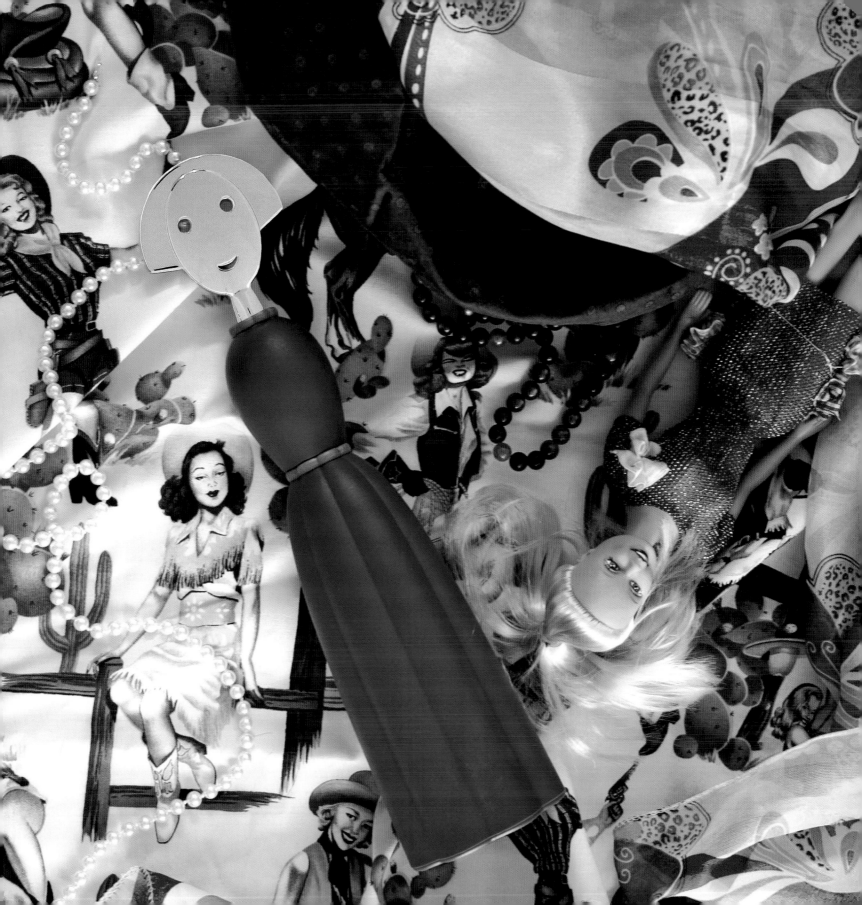

Anna **Pepper**

Alessandro Mendini created the face of **Anna** for Alessi, the Italian manufacturing company. She was introduced on a corkscrew, which surprisingly became Alessi's top-selling product. Soon after, a small family of products was developed using this same image. The pepper mill is one of the more whimsical in the group. Disguised as a doll, she does not reveal her purpose until you turn the head or look under the skirt.

STATISTICS
Designer: Alessandro Mendini
Manufacturer: Alessi
Date: 1998
Size: 11" x 2¾" diam.
Price I Paid: $79

FORM + FUNCTION

WHEN IT WORKS AS GOOD AS IT LOOKS

Whistling Bird Tea Kettle

Perhaps the most recognizable household design icon of the late 20th century is the Whistling Bird Tea Kettle by Michael Graves. It has appeared in every major home and design magazine and has been shown in a multitude of exhibitions. It is undoubtedly the most popular architect-designed product in this collection.

The story of the kettle began when Alessi, a successful Italian manufacturer, wanted to expand into the U.S. market and hired Graves, who was already well known for his post-modern architecture, a popular American style. The result of their collaboration was the now famous Whistling Bird Tea Kettle. Its classical shape blends references to Pop Art and Art Deco. The quirky colored elements are both decorative and functional: the blue handle signifies cool, while the red bird whistle indicates heat where the steam comes out.

This unique design succeeds in tapping into Americana themes and colors while looking modern and sophisticated. Graves has captured contemporary tastes to a "T."

Since 1985, over 1.3 million kettles have been sold!

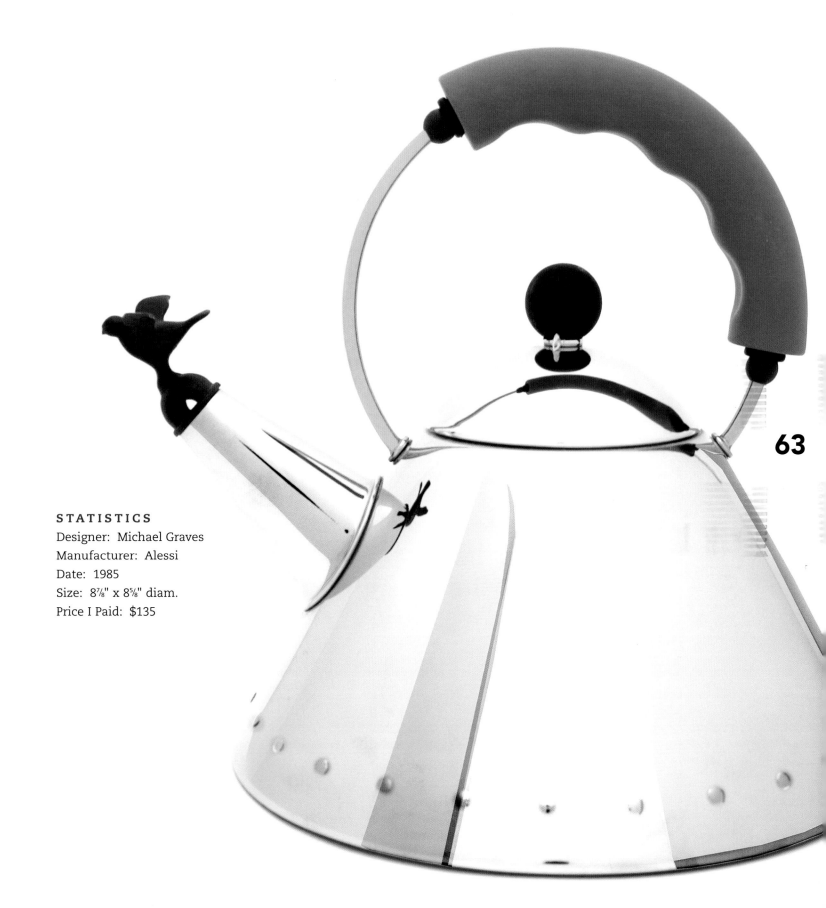

STATISTICS
Designer: Michael Graves
Manufacturer: Alessi
Date: 1985
Size: 8⅞" x 8⅝" diam.
Price I Paid: $135

63

XOX Table

These giant tic-tac-toe pieces create an exceptionally simple table without glue or nails. The two **X**'s slot together to form the base and the **O** sits on top, stabilized by four cut-out slots.

64

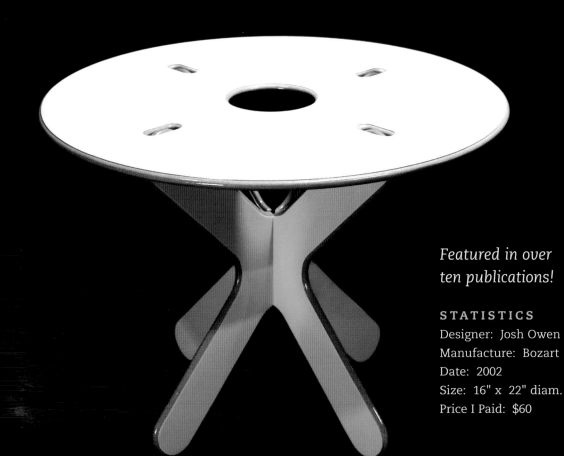

Featured in over ten publications!

STATISTICS
Designer: Josh Owen
Manufacture: Bozart
Date: 2002
Size: 16" x 22" diam.
Price I Paid: $60

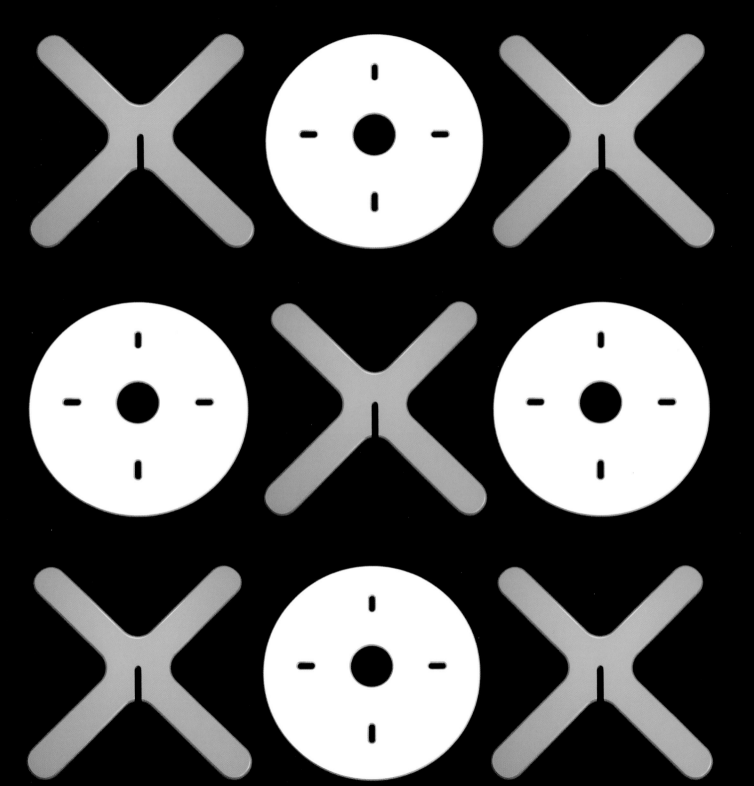

EVERY PRODUCT IN THE WOVO LINE OF SERVING PIECES LOOKS LIKE A WORK OF ART. The shapes resemble contemporary sculptures made of hand-blown glass or fine metals. In fact, they are all made of plastic.

The WOVO designers' intent was to bring "high design to the masses." They chose plastic because of its low cost and its ability, through the use of innovative technologies, to mimic the style, shape, and material of more expensive tableware. Every product in the line is exquisite, and they have changed forever our perception of this inexpensive material.

WOVO Thermal Carafe

The thermal carafe is one of WOVO's finest products. The silhouette is elegant, with a gracefully integrated handle. Simulating brushed and polished stainless steel, the carafe is made of plastic with a chrome-like finish—but you can't tell until you touch it. Functioning as a thermos with an insulated glass liner, it keeps liquids hot or cold. And at $32, the carafe is within anyone's budget.

67

STATISTICS
Designer: Smart Design
Manufacturer: WOVO
Date: 2002
Size: 11" x 7½" diam; 34 oz.
Price I Paid: $32

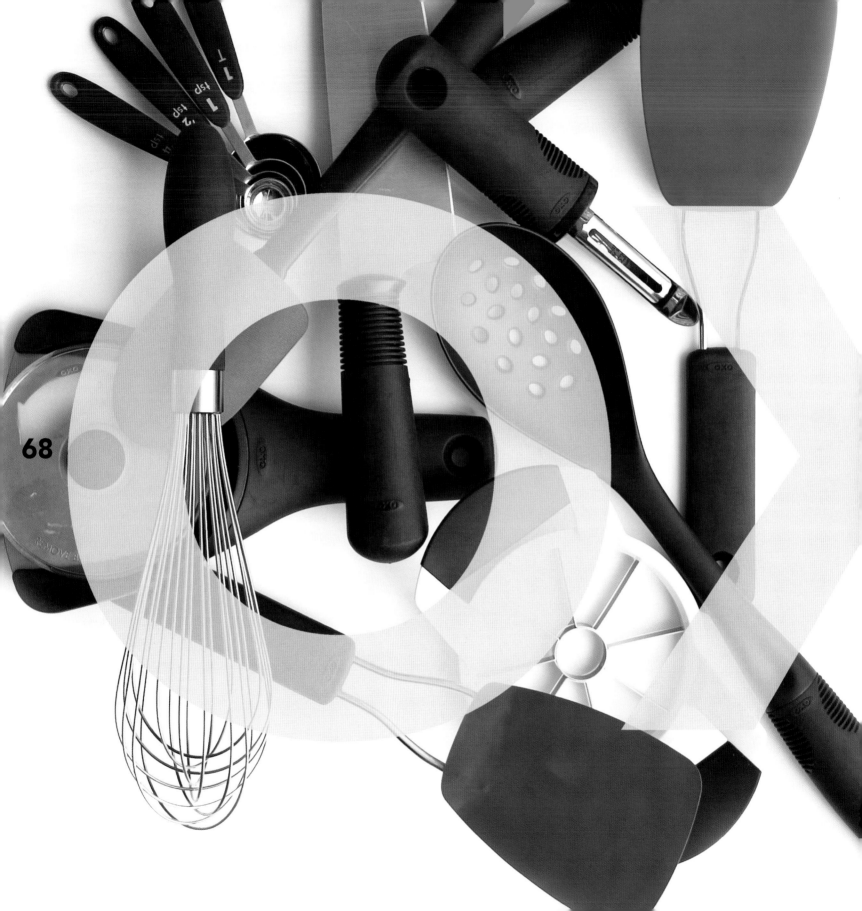

68

OXO **Products**

Necessity is the mother of invention.

This proverb definitely applies to the OXO kitchen products, which were created to solve a problem. Sam Farber, the former head of a very successful cookware company, noticed his wife struggling with her cooking utensils because of mild arthritis. He realized that this problem was shared by many people for a variety of reasons. The idea came to him to create a line of kitchen utensils that could be used by and appeal to anyone, with or without a disability.

His first group of 15 products was introduced into the marketplace in 1989 under the name OXO Good Grips. They were based on Farber's concept of Universal Design.

UNIVERSAL DESIGN

The design of products to be usable by as many people as possible: young and old, male and female, left-handed and right-handed, with or without special needs.

Over the next 15 years, the line grew to more than 500 items for cooking, cleaning, house repair, and gardening. **The success of the products is due to two factors: form and function.** They are ergonomically designed for comfort and performance and they have a strong aesthetic appeal.

OXO products have won more than 80 awards for good design. They are in the permanent collection of museums including the Smithsonian's Cooper-Hewitt National Museum of Design and the Museum of Modern Art in New York.

STATISTICS
Designer: Smart Design
Manufacturer: OXO, International
Date: 1989–present
Price I Paid: Variable

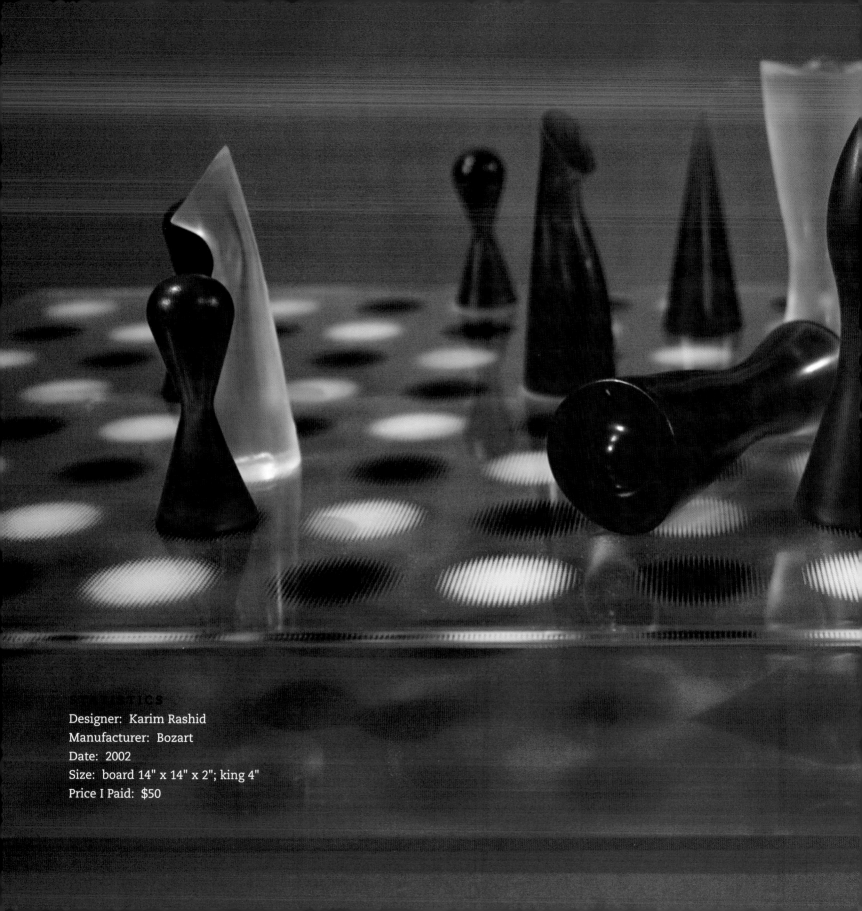

Designer: Karim Rashid
Manufacturer: Bozart
Date: 2002
Size: board 14" x 14" x 2"; king 4"
Price I Paid: $50

checkmate!

Karim Rashid Chess Set

One of the criteria for this collection is that an object be of museum quality. Karim Rashid's striking chess set—part of the permanent collection of the Philadelphia Museum of Art—is just that. It appeared in their 2002 exhibit "It's Your Move," which highlighted chess sets across many centuries and cultures, culminating with this contemporary set by Rashid.

His chess set has the familiar hierarchy of king, queen, knight, and pawn, but he has pushed them into abstract shapes using his unique "blobular" design vocabulary. Soft and bulbous, each piece is made of translucent rubber that is quite sensual to the touch. The playing surface is also a departure from the traditional checkerboard; it uses alternating colored dots instead of the black and white squares. Even its packaging displays Rashid's distinctive sense of design: the board is an acrylic box that opens up to store the pieces when not in use.

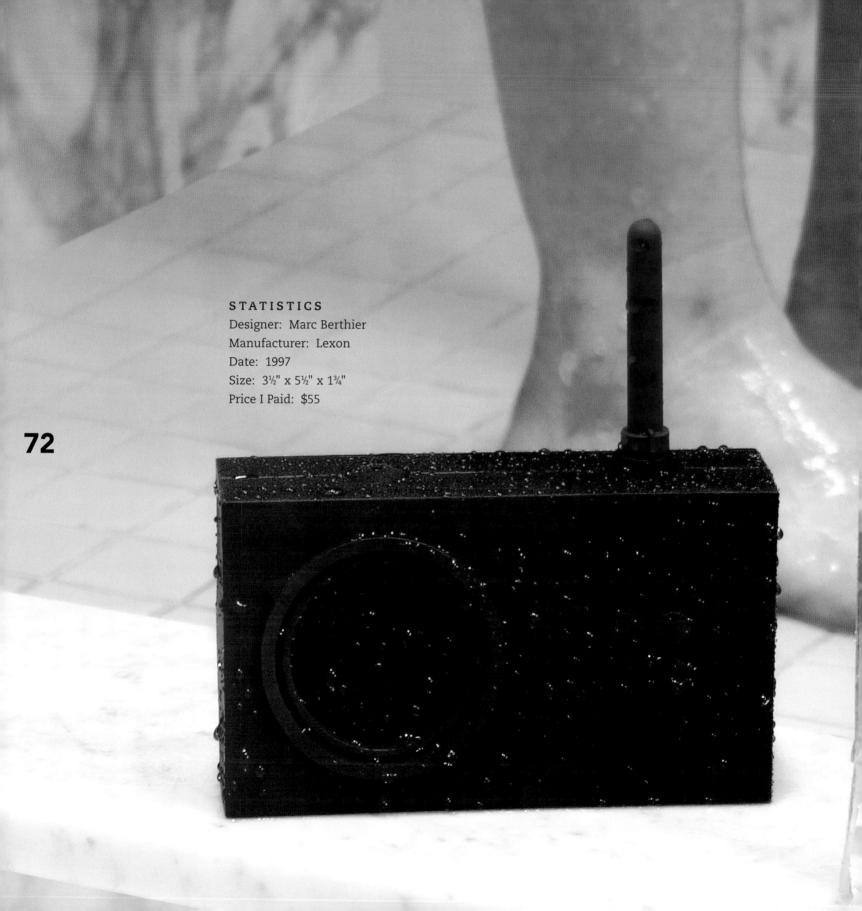

STATISTICS
Designer: Marc Berthier
Manufacturer: Lexon
Date: 1997
Size: 3½" x 5½" x 1¾"
Price I Paid: $55

This water-resistant radio was featured on the cover of *Time* magazine in March 2002. It won the New York 1999 Accent on Design Best Product Award for its innovative design, use of materials, and technology. In addition, it is in the permanent collections of the Museum of Modern Art in New York and the Centre Pompidou in Paris.

design
classic shape + elemental forms
easy-to-use controls

materials
synthetic rubber
splash + shock-resistant

technology
simple functions
antenna doubles as station tuner
good sound quality for small size

Tykho Rubber Radio

OUT
OF THE
CLOSET
and in the open!

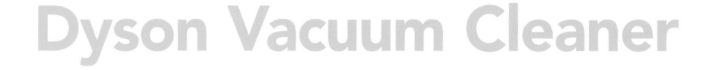

Dyson Vacuum Cleaner

Frustrated by vacuum cleaner bags that get clogged with dust, James Dyson set out to create the world's first bagless vacuum cleaner. He invested five years and developed 5,127 prototypes before finally introducing his first vacuum in 1983. Initially manufactured in Japan, the vacuums sold for $2,000. But their cost did not limit their appeal. Quite the contrary: these machines were so desirable they quickly became a status symbol.

Ten years later, Dyson developed a new version of his vacuum cleaner, which used Dual Cyclone™ technology to provide even greater suction power. And did it ever clean up! In less than two years, it became the best-selling vacuum cleaner in the United Kingdom.

It wasn't just the innovative technology, though, that made it revolutionary; it was also the design. Bright yellow like a power tool, this vacuum cleaner appealed to a previously untapped market segment: men. The canister was transparent, so you could see it fill up with dirt, and the attachments connected like construction toys. In short, this appliance was fun.

Today, the success of the Dyson vacuum cleaner is reflected in its billion-dollar business as well as its international acclaim. It has won numerous awards and been exhibited in museums around the world, all of which are listed proudly on the object itself.

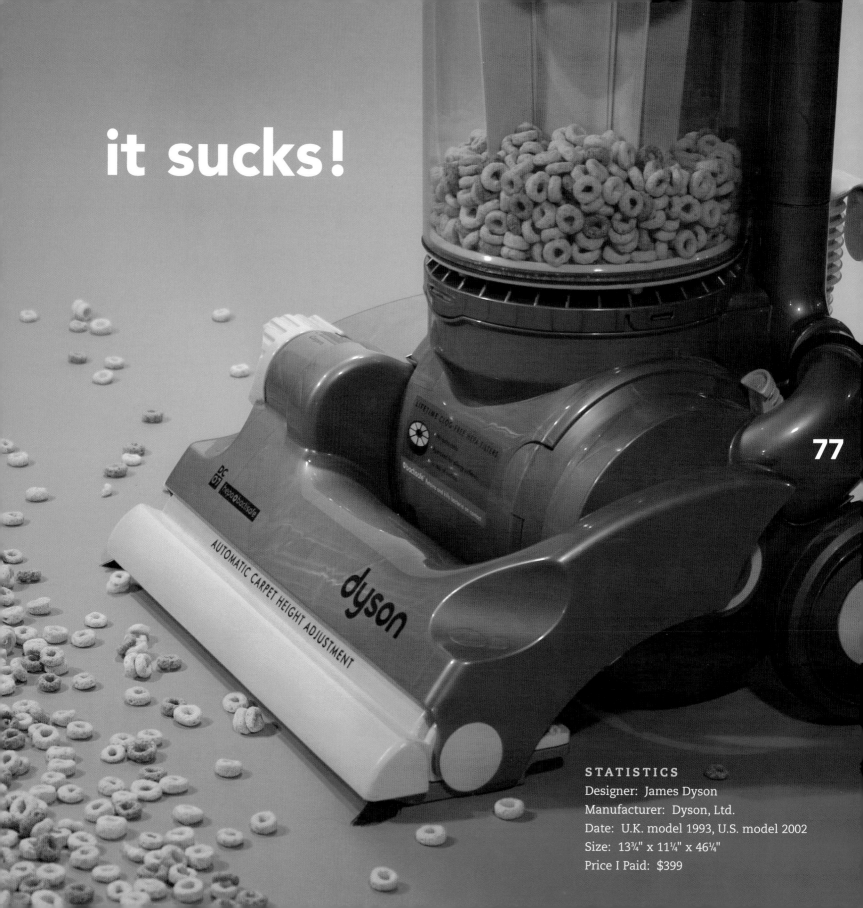

it sucks!

77

STATISTICS
Designer: James Dyson
Manufacturer: Dyson, Ltd.
Date: U.K. model 1993, U.S. model 2002
Size: 13¾" x 11¼" x 46¼"
Price I Paid: $399

Marc Newson
Hair Dryer

This is what you get when you cross Vidal Sassoon, the internationally renowned hair stylist, with Marc Newson, the internationally renowned designer of furniture, kitchenwares, and Olympic uniforms. Newson, who also designs aircraft interiors, has taken his streamlined high-tech style and applied it to the ordinary blow dryer. The shape is a variation on one he uses with most of his design work, from the daybed featured in a Madonna video to the prototype for an airplane exhibited at the Cartier Museum in Paris. His products and environments have been widely published and are in many museums.

Marc Newson was the only furniture/industrial designer honored in *Time* magazine's special issue (April 18, 2005) on the world's 100 most influential people in their fields.

STATISTICS

Designer: Marc Newson
Manufacturer: Vidal Sassoon
Date: 2002
Size: 7½" x 4" x 7½"
Price I Paid: $25

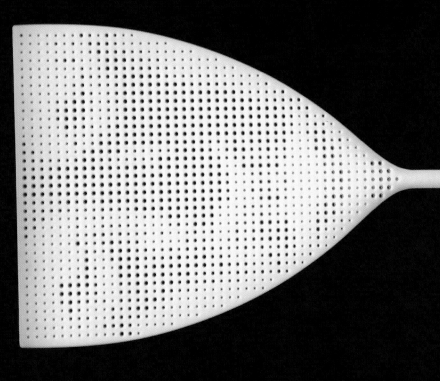

80

STATISTICS

Designer: Philippe Starck

Manufacturer: Alessi

Date: 1998

Size: 17¼" x 3¾"

Price I Paid: $14

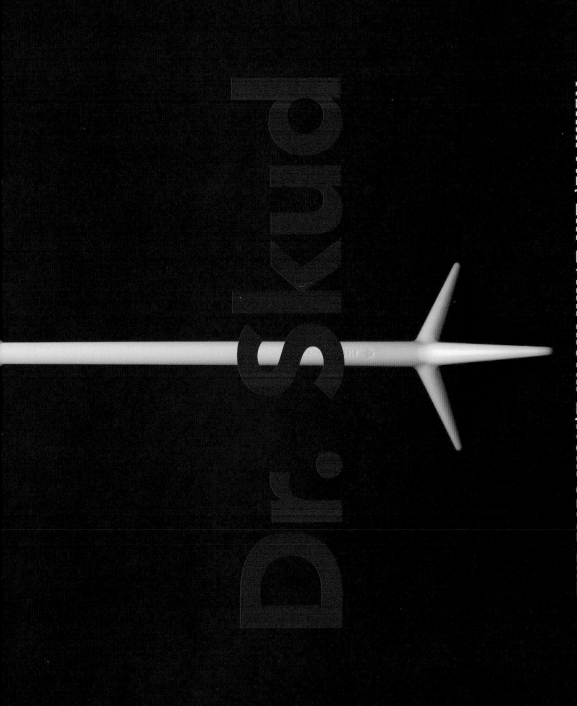

Dr. Skud

THE FLIES WON'T KNOW WHAT HIT 'EM WHEN
DR. SKUD COMES OUT OF THE CLOSET.

Who is Dr. Skud? A fly-swatting "missile" that targets its prey? Or just the alter ego of the designer, Philippe Starck, whose face appears through the perforations of this unusual flyswatter? Free-standing on its own tripod, it can be left on the shelf, ready to swat!

Dr. Skud has been widely recognized by the press, having been published in *Time* magazine, *I.D.* magazine, and *USA Today*. It also received the GOOD DESIGN Award in 1999.

81

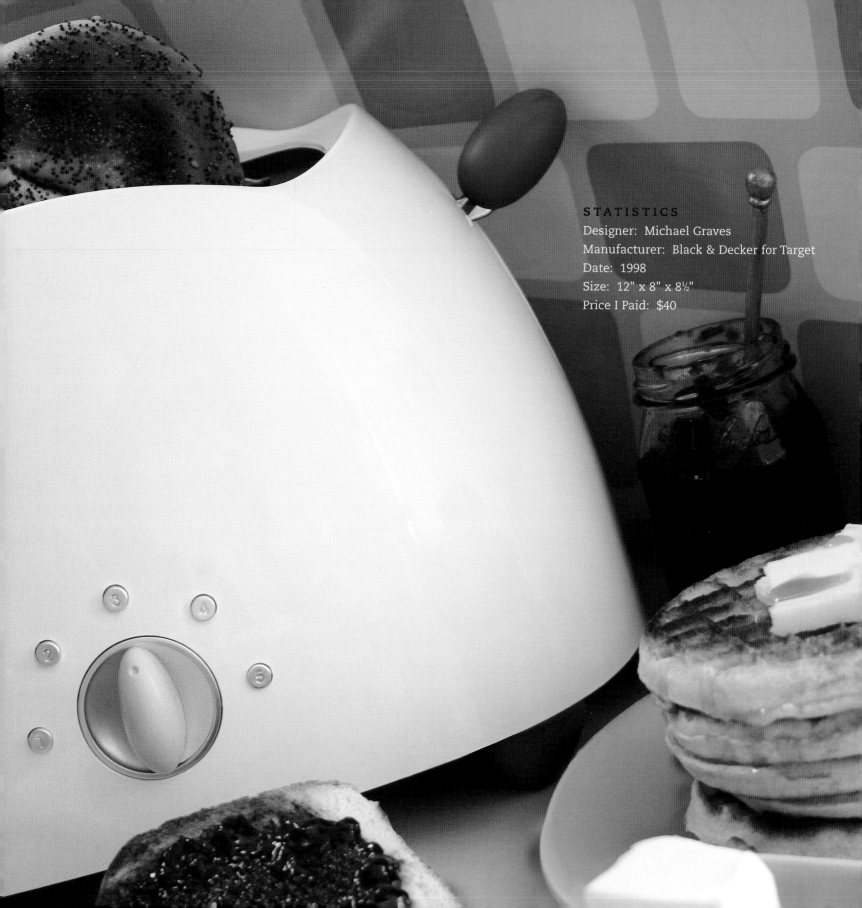

STATISTICS
Designer: Michael Graves
Manufacturer: Black & Decker for Target
Date: 1998
Size: 12" x 8" x 8½"
Price I Paid: $40

Toaster
for Target

In the 1990s, Target wanted to find a way to stand out among all the other mass-market stores. With great foresight, they chose to do this through design. To lead them in this direction, they hired Michael Graves to create a housewares program with identifiable design, styling, and packaging.

Over the next five years, he created more than 500 products: everything from cooking utensils and appliances to ironing boards and dust pans, clocks and telephones. Some of the many products in the line have won awards and stayed in production for years. The toaster is one of these products.

It was the first object Graves designed for Target
and epitomized his style for this new line. Its features included:

❶ **STRONG PROFILE:** classic shape with contemporary flair

❷ **PRIMARY COLOR PALETTE:** blue knob and yellow dial

❸ **PLAYFUL DETAILING:** the top resembles a slice of bread

AWARDS

1998 GOOD DESIGN Award (Chicago Athenaeum Museum of Architecture and Design)

1999 Industrial Design Excellence Award (sponsored by *Business Week*)

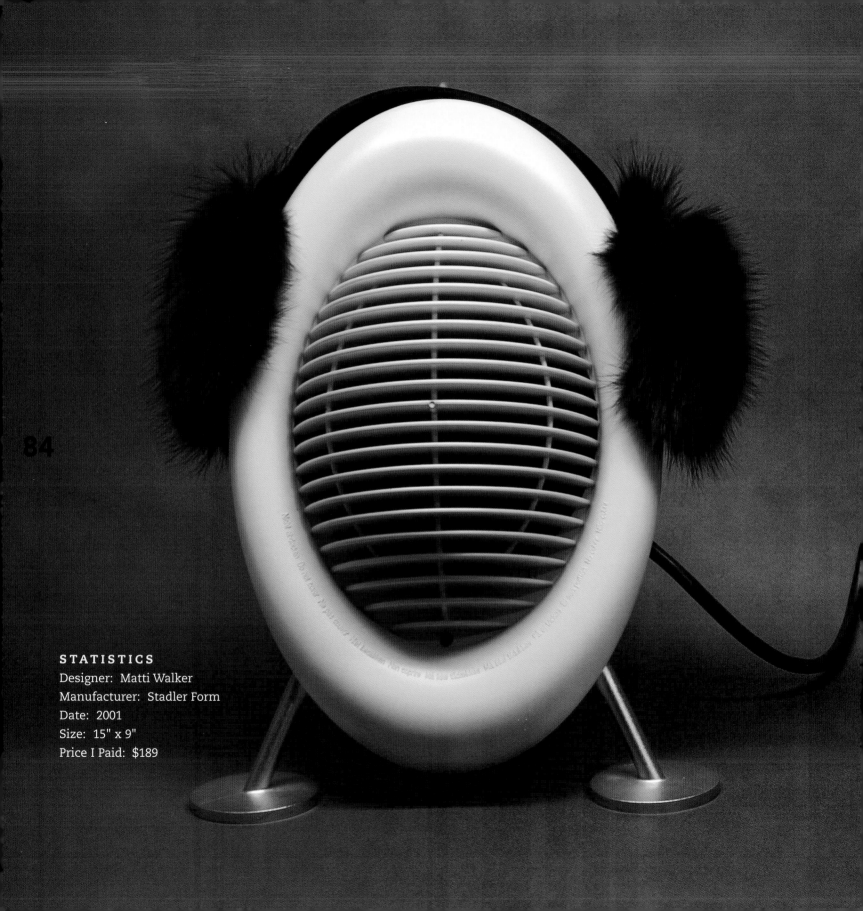

84

STATISTICS
Designer: Matti Walker
Manufacturer: Stadler Form
Date: 2001
Size: 15" x 9"
Price I Paid: $189

Max Heater

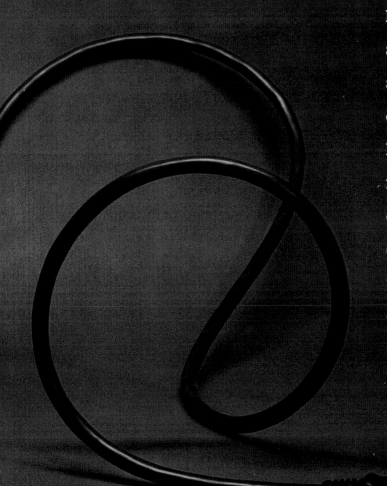

It's not hard to see the immediate appeal of Max Heater. Resembling an alien or robot like R2D2, this heater is cute. It won Best in Show at the 2002 New York International Gift Fair for its playful design and its precision engineering. It heats quickly, operates quietly, and is cool to the touch. The three feet provide stability, and at just over five pounds, it can easily be moved from room to room.

the lifetime average a person spends brushing their teeth is nine hundred and eleven hours.

47% wet the toothbrush before applying toothpaste. And here's a shocker: 73% of all children use too much toothpaste!

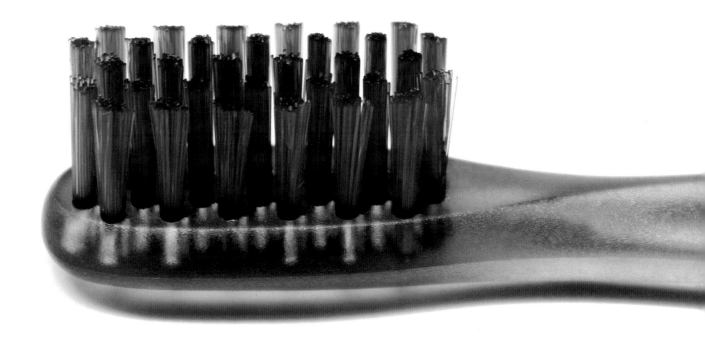

Dr. Kiss

Toothbrushes are rarely thought about in terms of their aesthetic appeal. But the designer Philippe Starck loves this challenge and has taken it on with Dr. Kiss. This toothbrush has a sculptural quality and makes a reference to a quill pen in an inkwell. The elegant handle has a flame-tipped silhouette and stands upright in the accompanying pedestal. Drainage holes in the base keep Dr. Kiss fresh and clean.

STATISTICS
Designer: Philippe Starck
Manufacturer: Alessi
Date: 1998
Size: 8" x 2" diam.
Price I Paid: $15

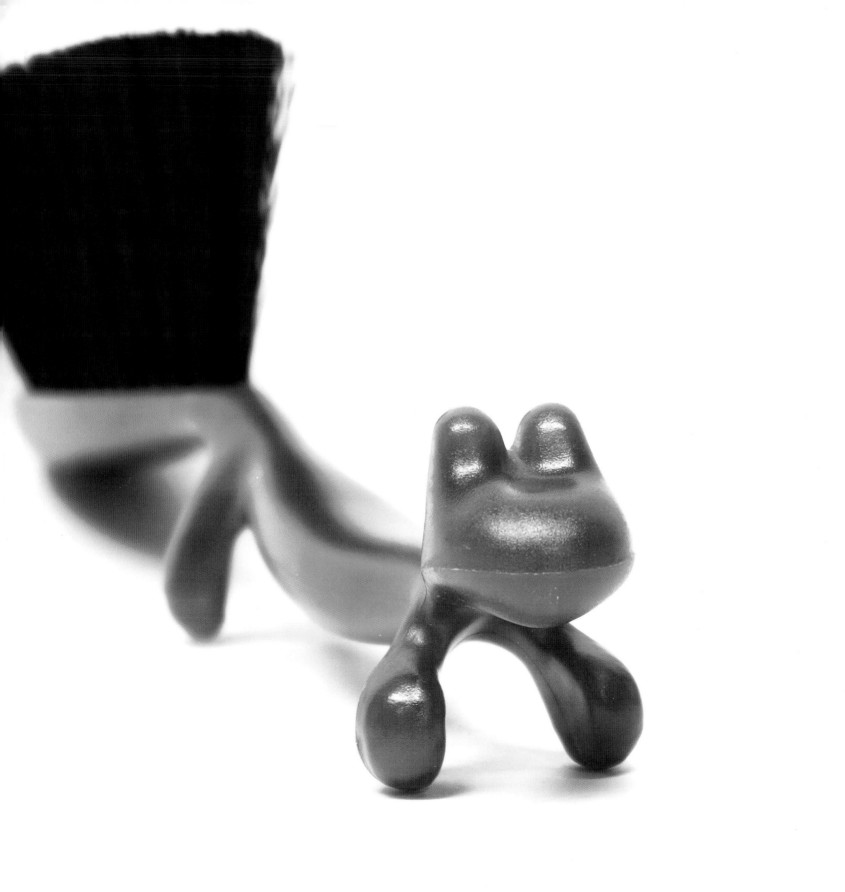

ADULT TOYS

(no kidding around)

DUSTIN

Dustpan + Brush

It's only a dustpan, but it has made prime time—DUSTIN has been featured as a regular on the set of NBC's **Friends**.

Koziol has created a quirky cleaning tool to add some fun to the boring task of housekeeping. Resembling a squirrel with a bushy tail climbing a tree branch, DUSTIN Dustpan looks so much like a toy, you may even trick your kids into helping!

STATISTICS
Designer: Frank Person and Jan Hansen
Manufacturer: Koziol
Date: 1998
Size: 16" x 9½" x 3½"
Price I Paid: $30

91

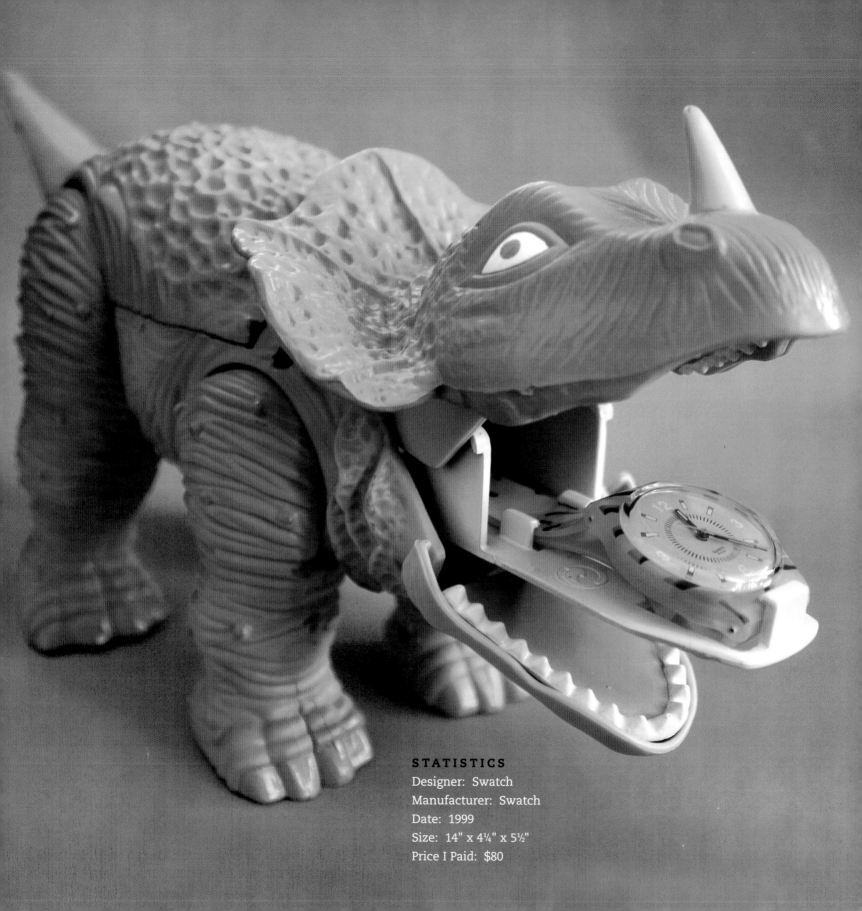

STATISTICS
Designer: Swatch
Manufacturer: Swatch
Date: 1999
Size: 14" x 4¼" x 5½"
Price I Paid: $80

Skeleton Loomi
Swatch

Why are Swatch watches in the collection?

THEY ARE COLLECTED FOR THEIR UNUSUAL PACKAGE DESIGN. Inventive, well-made, and witty packaging can give a product a lot of added value and even become the product itself.

With its mouth closed, this dinosaur looks like a toy. But when the tail is lifted, the mouth opens and the tongue extends to reveal the watch inside. Brilliant! The creative packaging gives Skeleton Loomi its added value and pizzazz. Like most Swatch watches, this one was in production for only one season. It was purchased for $80 in 1999 and has since been spotted on the Internet for about $150.

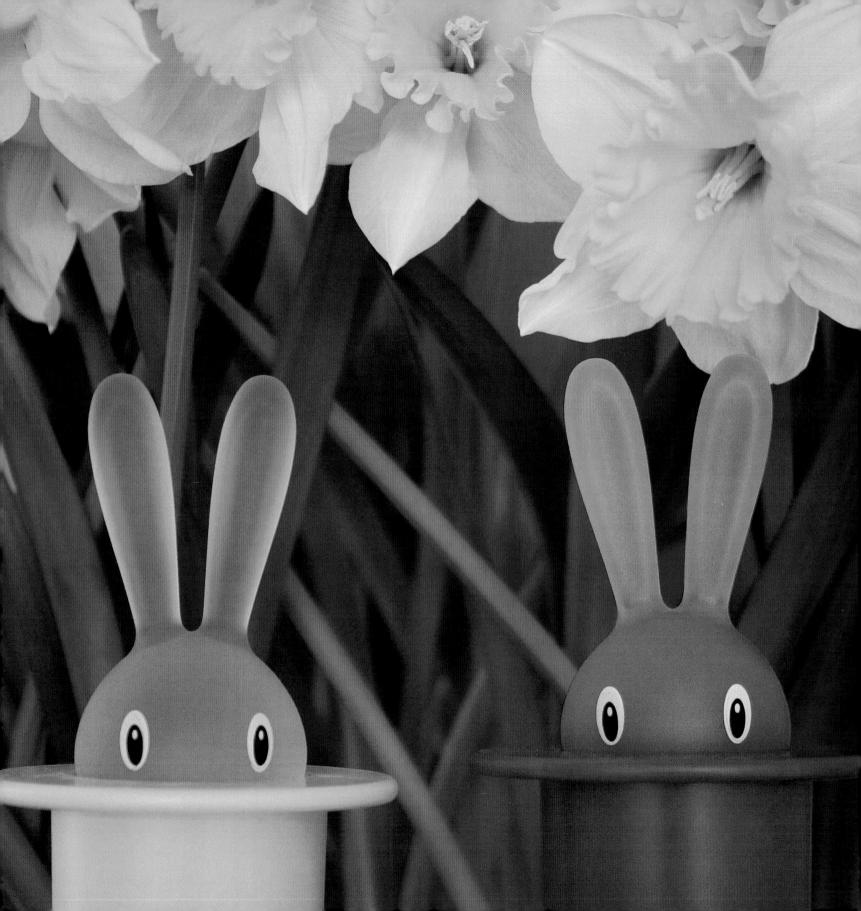

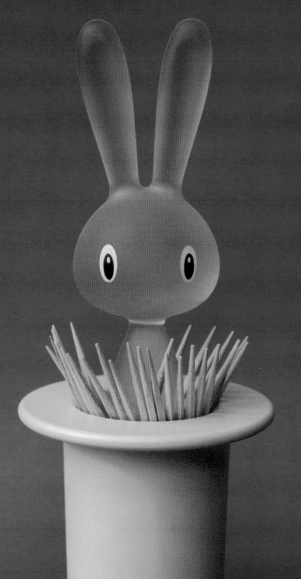

STATISTICS
Designer: Stefano Giovannoni
Manufacturer: Alessi
Date: 1998
Size: 5½" x 1¾" diam.
Price I Paid: $30

Magic Bunny

Pull the bunny out of the hat and VOILA! A toothpick holder? This element of surprise creates the magic in Stefano Giovannoni's design. Lighthearted yet thoughtful, his approach demonstrates a personal vision that is not limited by the way things have always been done.

Ship Shape
Butter Dish

Disguised as a ship, this butter dish is made of high-quality translucent and opaque colored plastics. The ship's "steam" pulls out to reveal a butter knife, making this an all-in-one butter "boat."

(For people who like to play with their food, this is the perfect toy.)

STATISTICS
Designer: Stefano Giovannoni
Manufacturer: Alessi
Date: 1998
Size: 6" x 3¼" x 6"
Price I Paid: $33

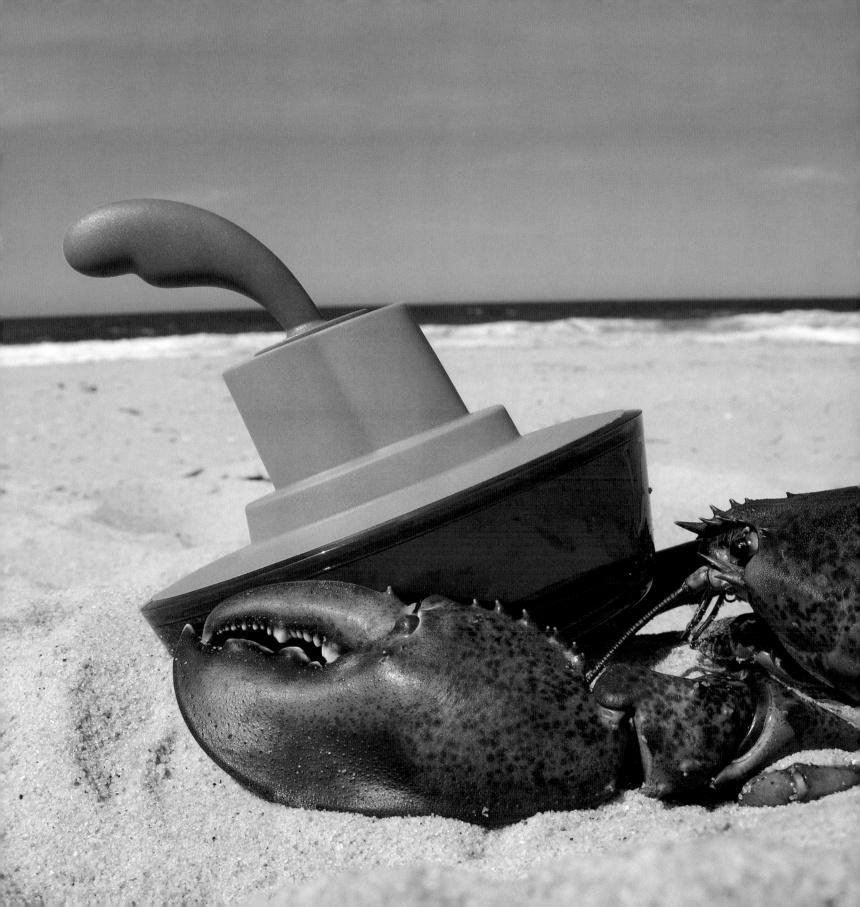

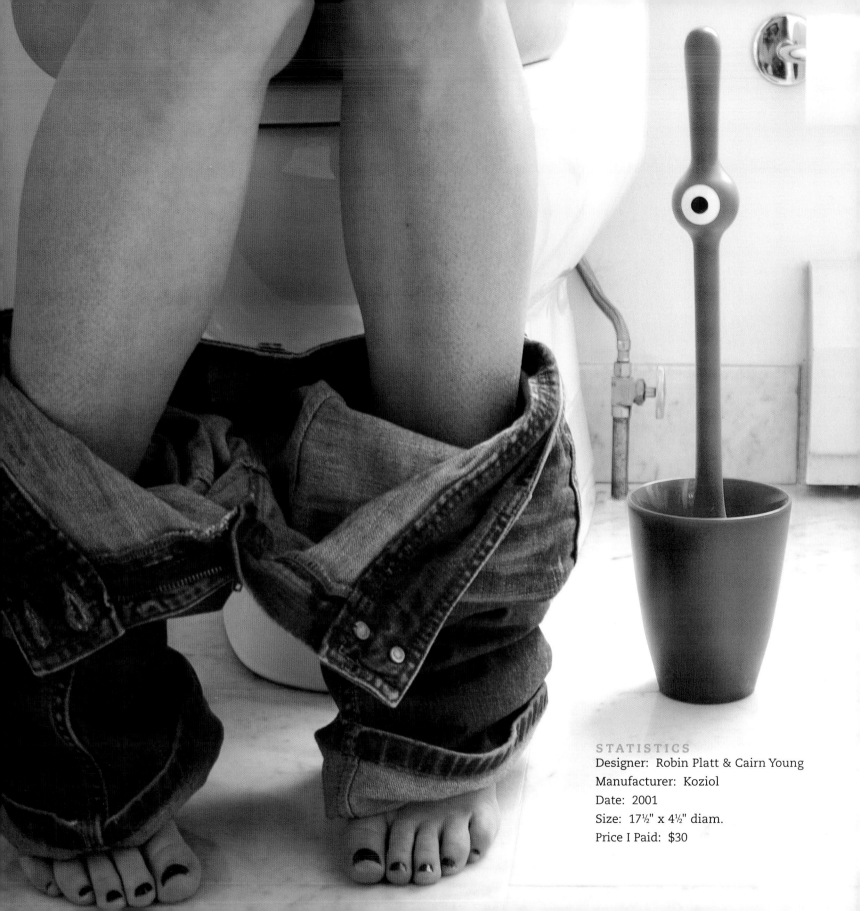

STATISTICS
Designer: Robin Platt & Cairn Young
Manufacturer: Koziol
Date: 2001
Size: 17½" x 4½" diam.
Price I Paid: $30

And you thought you were alone…

TOQ Toilet Brush

This one-eyed "alien" staring at your behind can make you feel a
bit uncomfortable, but that is the intention.
Creepy, bizarre, and downright funny, Koziol products
are known for having a wry sense of humor.
They try to make the mundane tasks of everyday chores just
a bit more fun.
Made of durable plastic with a hard-bristled brush,
TOQ is a strong presence in anyone's bathroom.

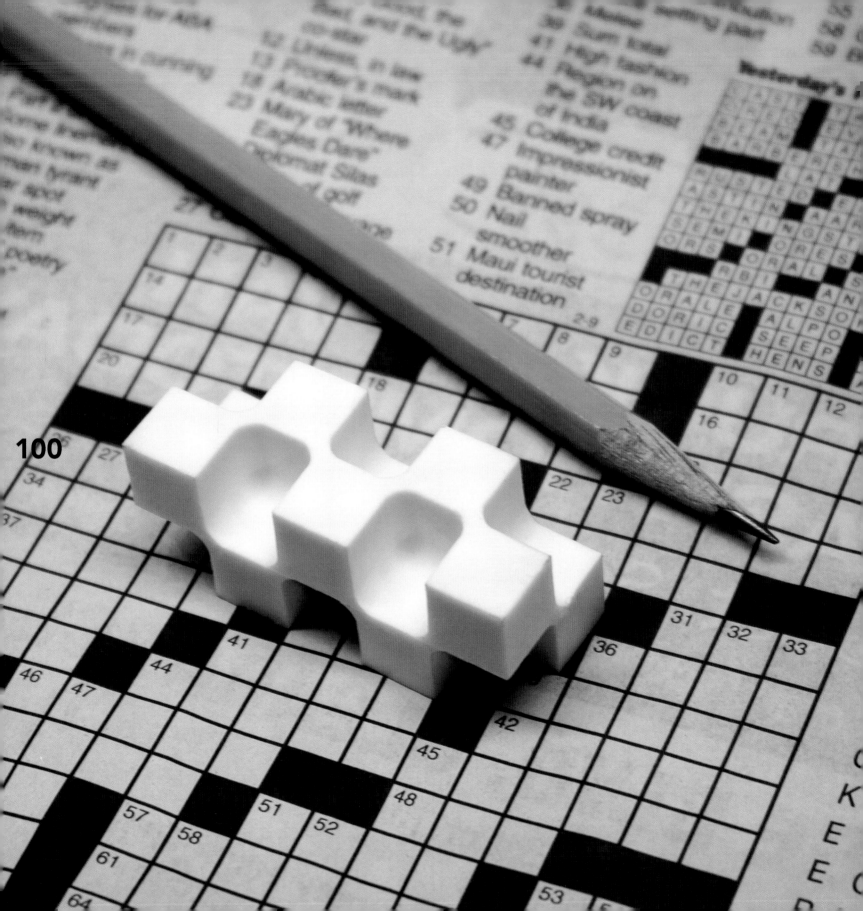

100

Complex building block?
Child's construction toy?

Not even close! This is a precision rubber eraser with 24 crisp corners that make it possible to erase the most difficult areas. It was featured in MoMA's 2004 exhibition "Humble Masterpieces."

Although modest in size and price, these objects are true masterpieces of the art of design and are deserving of our admiration.

Paola Antonelli, Curator of Architecture and Design, The Museum of Modern Art, New York

STATISTICS
Designer: Hideo Kanbara
Manufacturer: Kokuyo Co., Ltd.
Date: 2001
Size: ¾" x 2" x ¾"
Price I Paid: $3

White Eraser

NOT WHAT it seems

(no fooling!)

Paper**weight**

Don't trash this!

It may look like trash, but this crumpled paper is made of silk-screened vinyl

104 acetate and is weighted with a piece of steel in the middle. The designer, Tibor

Kalman, was known for his wit and whimsy and for using everyday imagery

in surprising ways. He was one of the first, in the early 1980s, to rethink the

design of common objects, helping to fuel the current demand today.

As a graphic designer, Kalman was most famous (and infamous) for his

controversial covers for the Benetton publication Colors. The press loved his

work, and the San Francisco Museum of Modern Art gave him a solo show

in 1999.

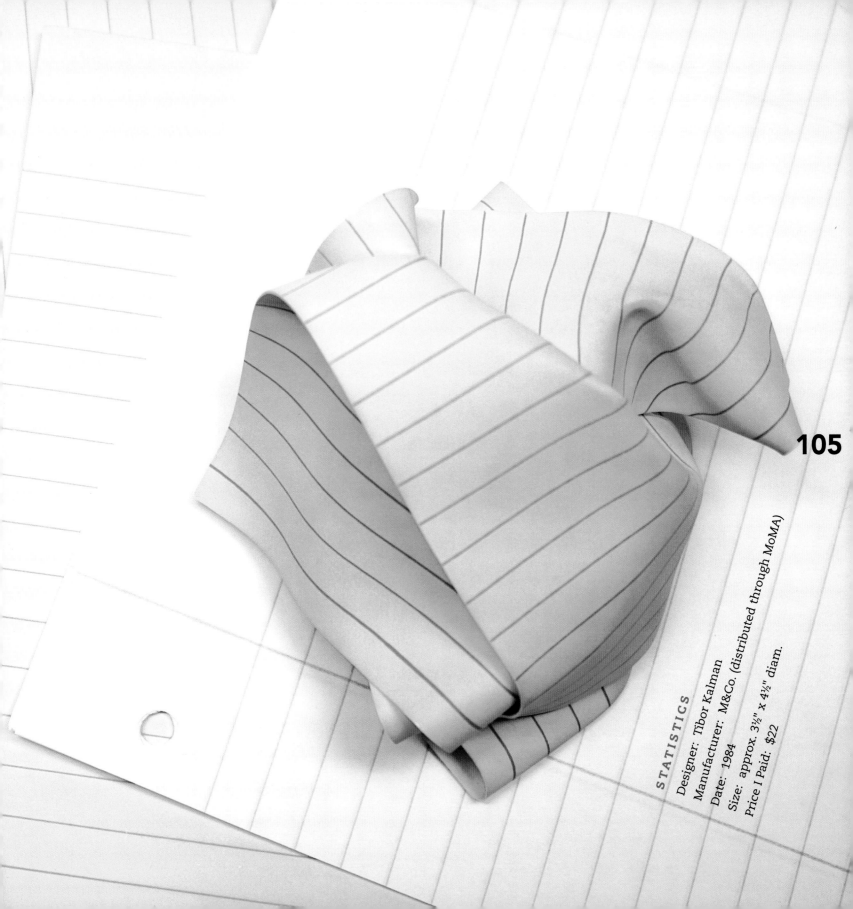

105

STATISTICS

Designer: Tibor Kalman
Manufacturer: M&Co. (distributed through MoMA)
Date: 1984
Size: approx. 3½" x 4½" diam.
Price I Paid: $22

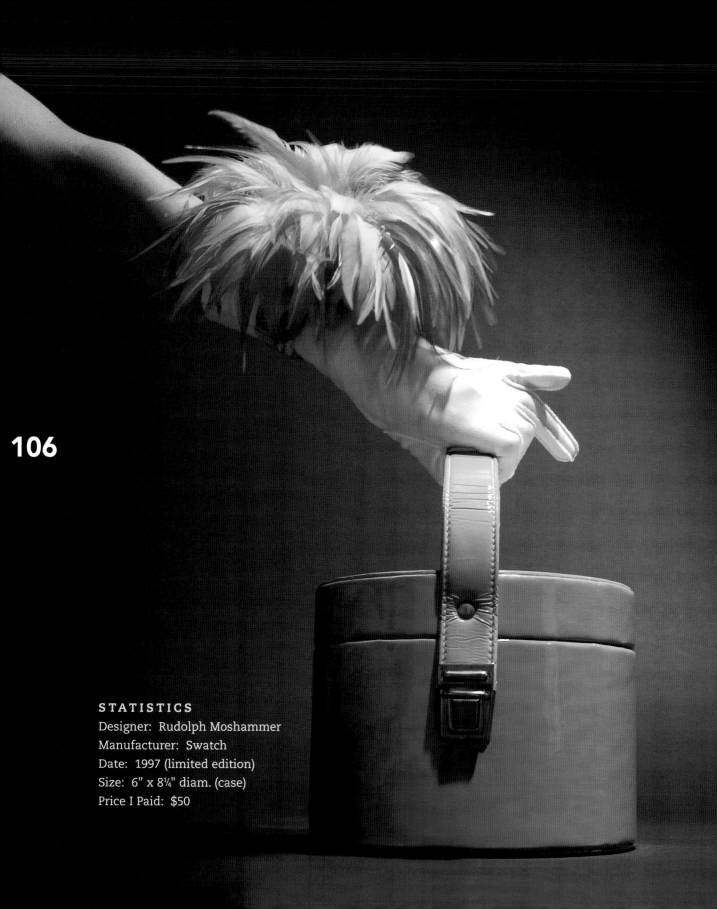

106

STATISTICS
Designer: Rudolph Moshammer
Manufacturer: Swatch
Date: 1997 (limited edition)
Size: 6" x 8¼" diam. (case)
Price I Paid: $50

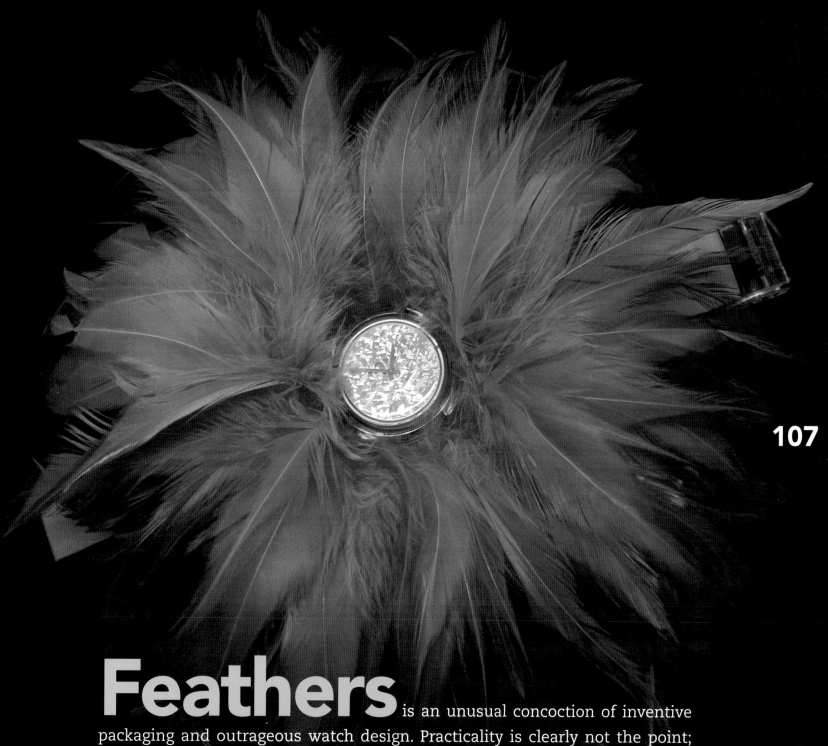

Feathers is an unusual concoction of inventive
packaging and outrageous watch design. Practicality is clearly not the point; getting attention is! This Pop Swatch Special is a mass of exotic orange feathers attached to an elastic band. It comes in the unlikely packaging of a little girl's beauty box. When it is opened, the feathers pop out for a delightful surprise.

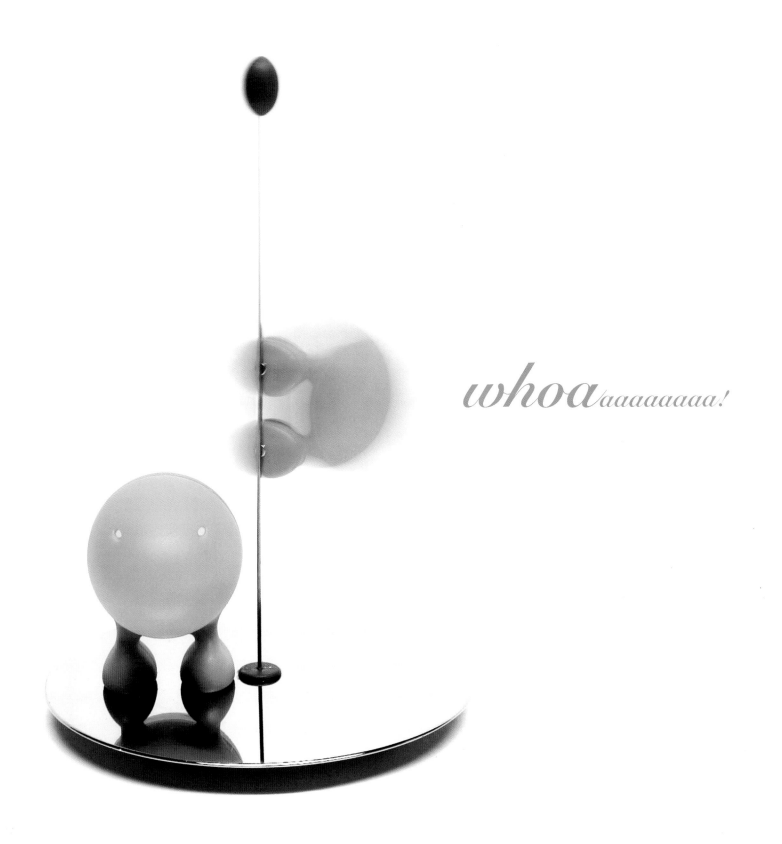

*whoa*aaaaaaaa!

Lilliput

Named after the little people in *Gulliver's Travels*, these salt and pepper shakers could be mistaken for a child's toy. The multi-award-winning designer Stefano Giovannoni applied a high level of thought to every aspect of their design. There are magnets on the Lilliputs' feet that allow them to spin around the metal pole or stick to the metal base. The knob at the top of the pole makes it easy to pick up the shakers and pass them as a pair.

STATISTICS
Designer: Stefano Giovannoni
Manufacturer: Alessi
Date: 1993
Size: shaker 2" x 2"; base 6" x 4¼" diam.
Price I Paid: $45

STATISTICS

Designer: Philippe Starck

Manufacturer: Alessi

Date: 1990

Size: 11½" x 4¾" diam.

Price I Paid: $75

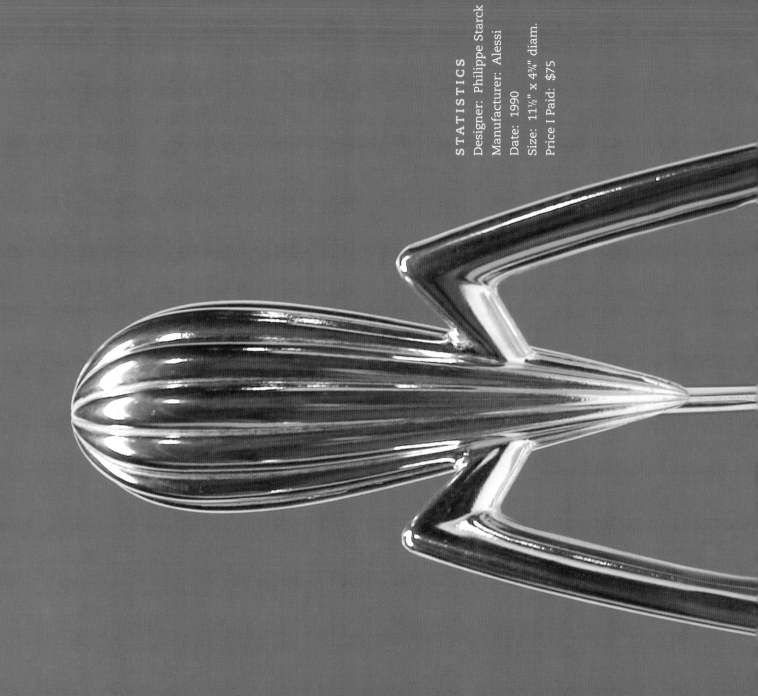

Juicy Salif

Philippe Starck's best-known product is Juicy Salif. It was one of the very first designs to start the now popular trend of taking ordinary household products and transforming them into objects of desire. Although this fantastic-looking juicer was initially criticized for its seeming impracticality, it actually works quite well. And far from being a lemon, it proved to be a best-seller for its manufacturer, Alessi.

Design icon of the late 20th century

Widely published and in the permanent collections of museums around the world

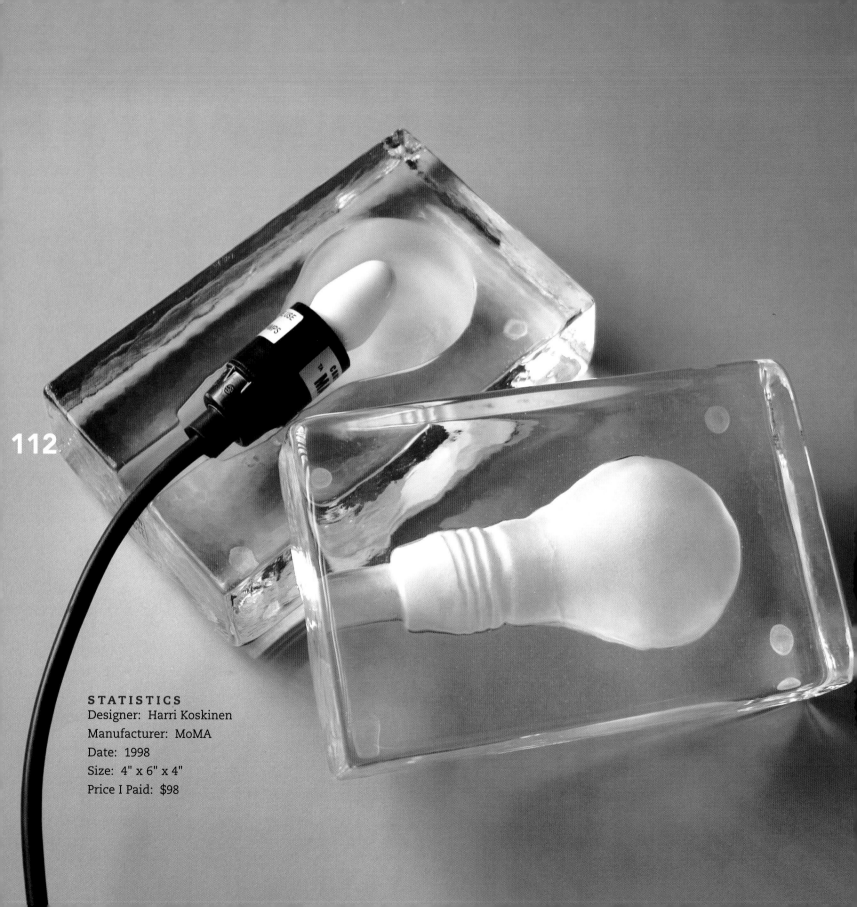

112

STATISTICS
Designer: Harri Koskinen
Manufacturer: MoMA
Date: 1998
Size: 4" x 6" x 4"
Price I Paid: $98

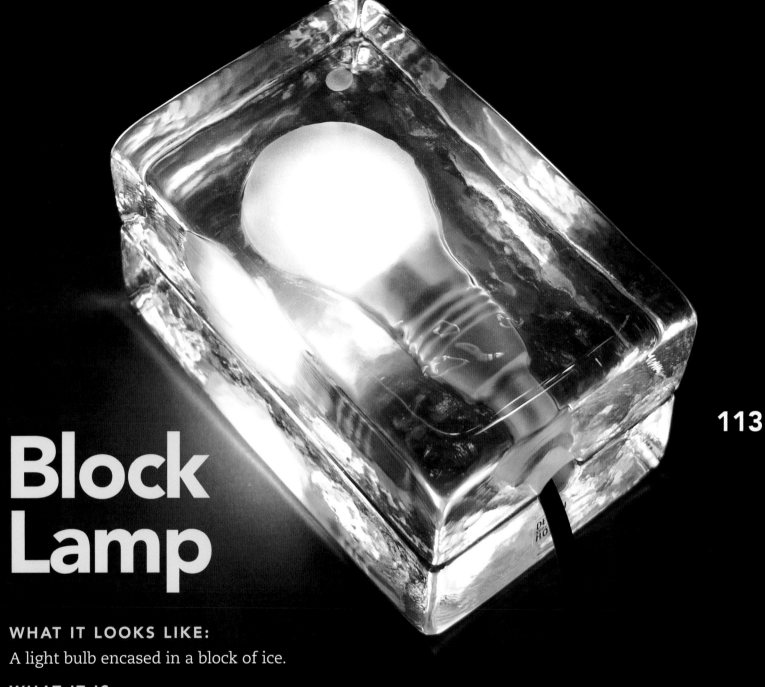

Block Lamp

WHAT IT LOOKS LIKE:

A light bulb encased in a block of ice.

WHAT IT IS:

Two pieces of glass block that open up to reveal a nightlight bulb resting inside the etching of a normal bulb.

AWARD:

Best Product, Accent on Design Show, New York, 1999

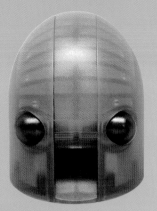

Hannibal

Ancient history inspired the design of this tape dispenser/paperweight. The connection may be arbitrary, but the result is delightful. In the closed position, it is a paperweight that resembles the helmet of the warrior Hannibal. When it is opened, it becomes an elephant-shaped tape dispenser. The translucent plastic reveals the outline of the elephant's feet and ribs.

AWARDS:

I.D. Magazine Annual Design Review Winner, 1998

Good Design International Award, 1998

STATISTICS

Designer: Julian Brown

Manufacturer: Rexite

Date: 1998

Size: 3¼" x 4" x 3¾"

Price I Paid: $60

HANNI BAL

HANNIBAL CROSSED
THE ALPS ON ELEPHANTS
TO CONQUER ROME
IN 227 B. C.

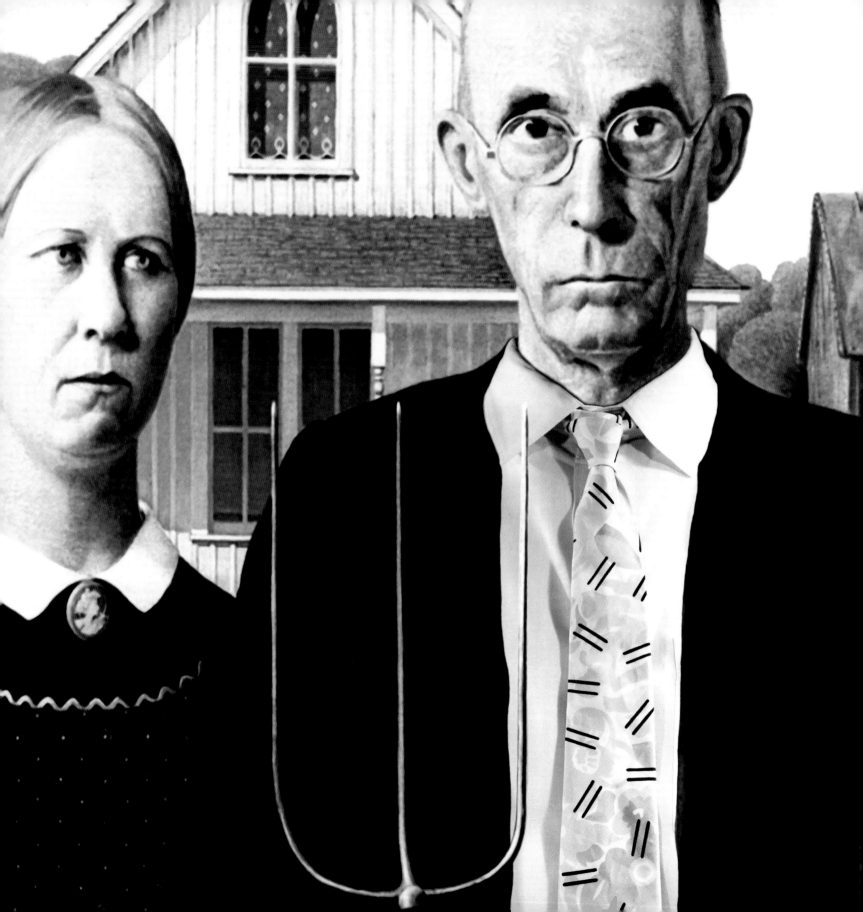

ARTFULLY
DESIGNED

Creative canvas

Necktie with
Grandmother Pattern

Robert Venturi is a world-famous architect who came to the forefront of design in the 1960s. With wit and whimsy, he used familiar and historical images in unexpected ways. Venturi branched out into furniture design in the early 1980s, mimicking major historical styles. Instead of using carved wood and upholstery, he fashioned molded plywood and plastic laminate in the shapes of traditional chairs. Perhaps the best-known motif used on his furniture was the "Grandmother" pattern. Based on a vintage tablecloth design, the pattern was modified to give it a totally new and contemporary look. First, color and pattern were used to enhance its sweetness; then, bold black dashes were superimposed to change rhythm, scale, and color. The pattern would go on to adorn dishes and textile lines. Although its application on a necktie may seem unlikely, it is an insider's joke among designers and architects, who know the pattern well and see it as an icon of the post-modern era.

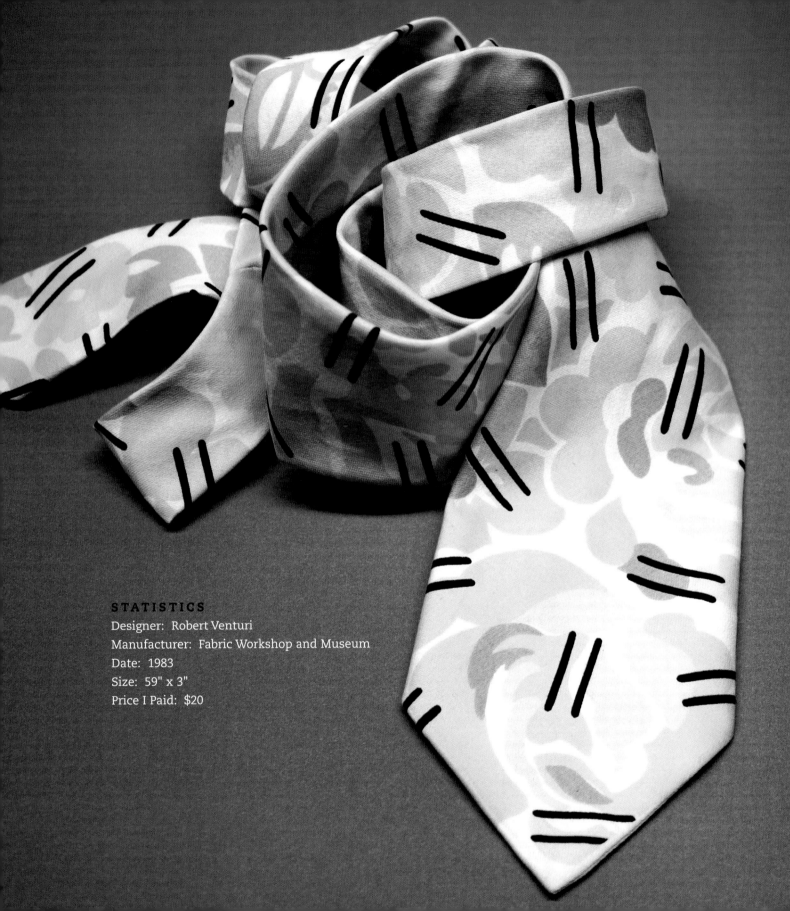

119

STATISTICS
Designer: Robert Venturi
Manufacturer: Fabric Workshop and Museum
Date: 1983
Size: 59" x 3"
Price I Paid: $20

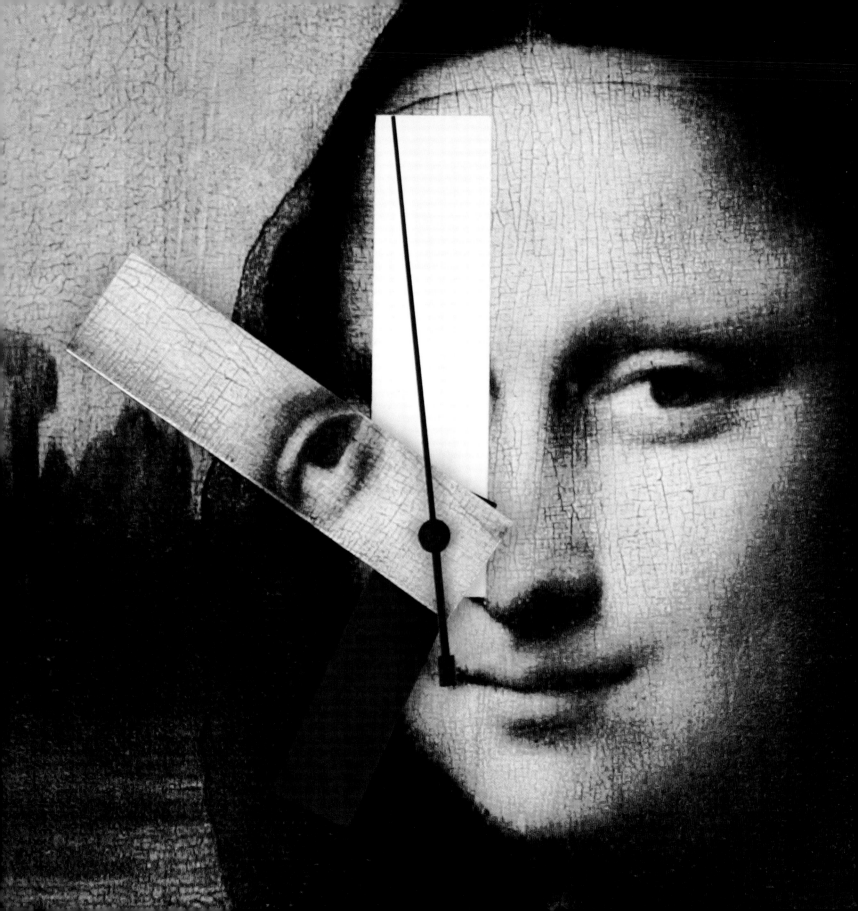

Mona Lisa Clock

IS IT POSSIBLE TO SEE SOMETHING DIFFERENTLY THAT WE'VE SEEN A THOUSAND TIMES BEFORE?

Mona Lisa Clock, which bears a close-up shot of the famous face, achieves this wondrous feat. Part of the painting is imprinted on the minute hand so you see the image in its entirety only at noon and midnight.

When the clock first came out, it caused quite a stir. Was this a respectful reference or a display of irreverence? Was it about time or timelessness? Or perhaps it was just a thoughtful and witty look at the world we too often take for granted.

THE CLOCK ITSELF IS ALSO A WORK OF ART. Carefully crafted, it was made with a photo-transfer process on heavy-gauge aluminum. The clock was publicized as an exhibition piece and featured frequently in the press, going on to achieve great commercial success.

Converting a timeless masterpiece into a masterful timepiece

121

STATISTICS
Designer: Constantin Boym
Manufacturer: Elika
Date: 1990
Size: 7¾" x 9¾"
Price I Paid: $100

The Flower Ball

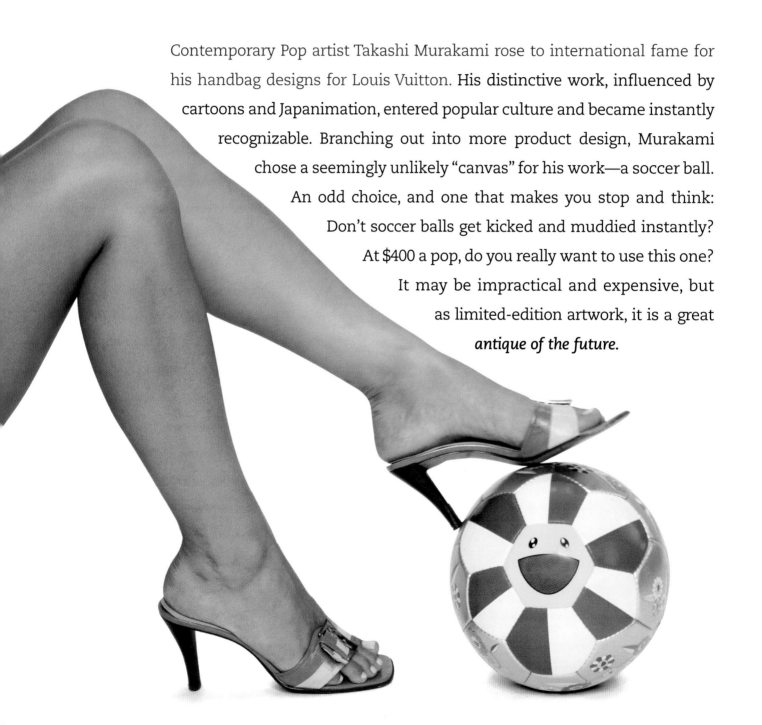

Contemporary Pop artist Takashi Murakami rose to international fame for his handbag designs for Louis Vuitton. His distinctive work, influenced by cartoons and Japanimation, entered popular culture and became instantly recognizable. Branching out into more product design, Murakami chose a seemingly unlikely "canvas" for his work—a soccer ball. An odd choice, and one that makes you stop and think: Don't soccer balls get kicked and muddied instantly? At $400 a pop, do you really want to use this one? It may be impractical and expensive, but as limited-edition artwork, it is a great *antique of the future.*

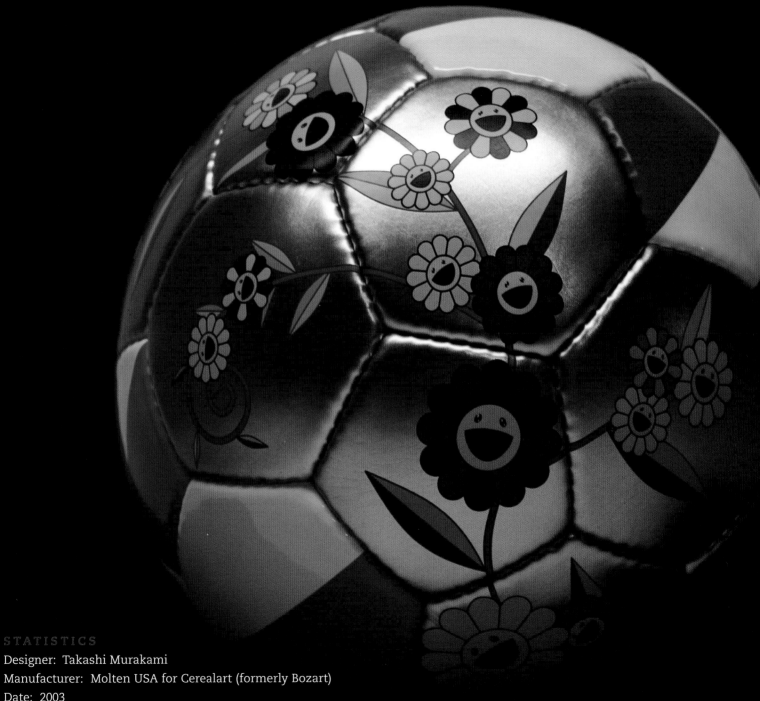

STATISTICS

Designer: Takashi Murakami

Manufacturer: Molten USA for Cerealart (formerly Bozart)

Date: 2003

Size: 8" diam.; size 5

Price I Paid: $400

124

STATISTICS

Designer: Annie Leibovitz
Manufacturer: Swatch
Date: 1996
Size: 9"
Price I Paid: $60

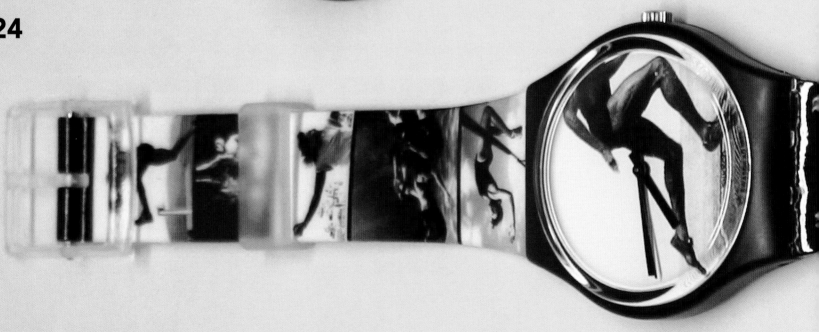

Swatch

ONE OF THE MOST RENOWNED photographers working today is Annie Leibovitz, best known for her work with celebrities and for major advertising campaigns. In 1996 she went to Atlanta to photograph the summer Olympics. Her photographs were published in a book and became the basis for this Swatch.

Leibovitz created the watch using her action shots of athletes at the peak of their performances. The pictures on the band are lined up in a series, resembling a strip of film negatives. The watch face is a close-up of a runner's body captured mid-race with muscles straining.

The watch comes in a carefully designed package that mimics the black case of a photographer's portfolio and includes a magnifying glass similar to those used by professional photographers. These added features, along with Leibovitz's involvement in the design, give the watch its value for this collection.

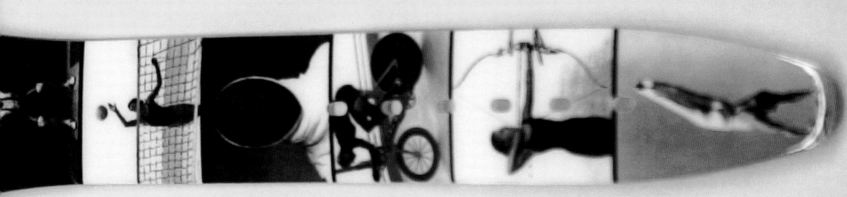

for 1996 Atlanta Olympics

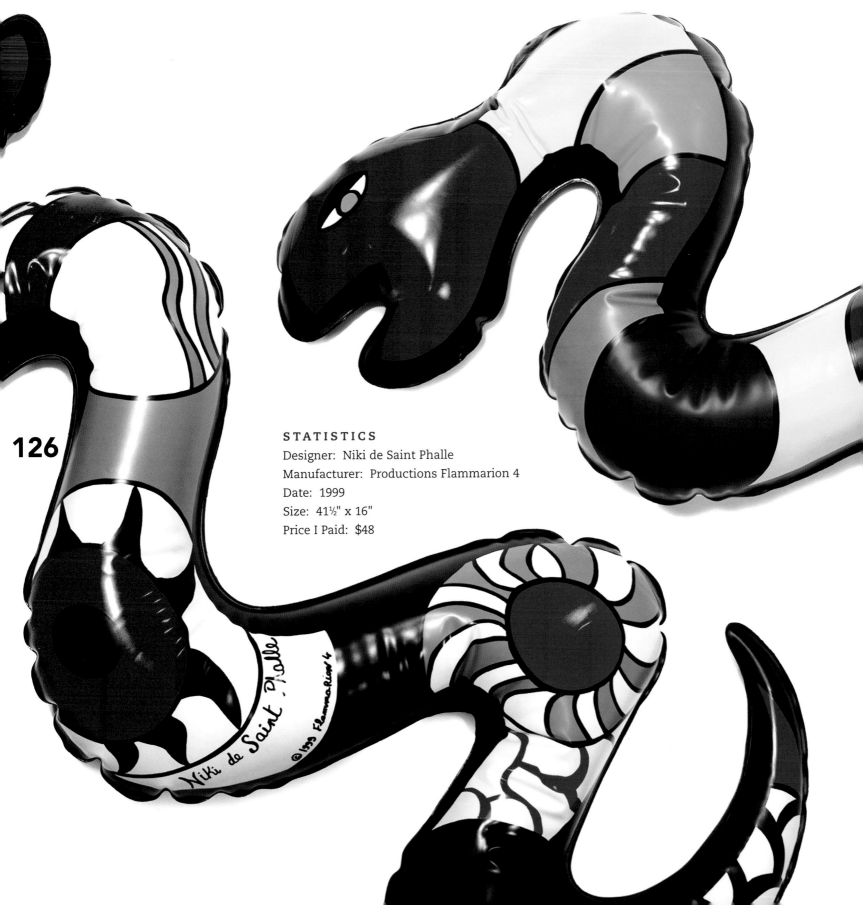

STATISTICS
Designer: Niki de Saint Phalle
Manufacturer: Productions Flammarion 4
Date: 1999
Size: 41½" x 16"
Price I Paid: $48

Niki de Saint Phalle Snake

The French artist Niki de Saint Phalle was renowned for her bold and graphic work, as well as her distinctive perfume bottle of colorful intertwined snakes. A sculptor, painter, and illustrator, she took some of her most popular images and mass-produced them as a line of inflatable art.

The snake is a common theme throughout her work. This design is based on one of the sculptures she did for the water garden in front of the Centre Pompidou in Paris. The art is different on each side, with front and back serving as separate canvases.

WHY IT IS IN THE COLLECTION: Often, when an artist's work is applied to a product, it is done so after the artist's death. In this case, Niki de Saint Phalle herself created the inflatable sculpture from her own original art. It is this direct involvement in the project that gives the snake its intrinsic value.

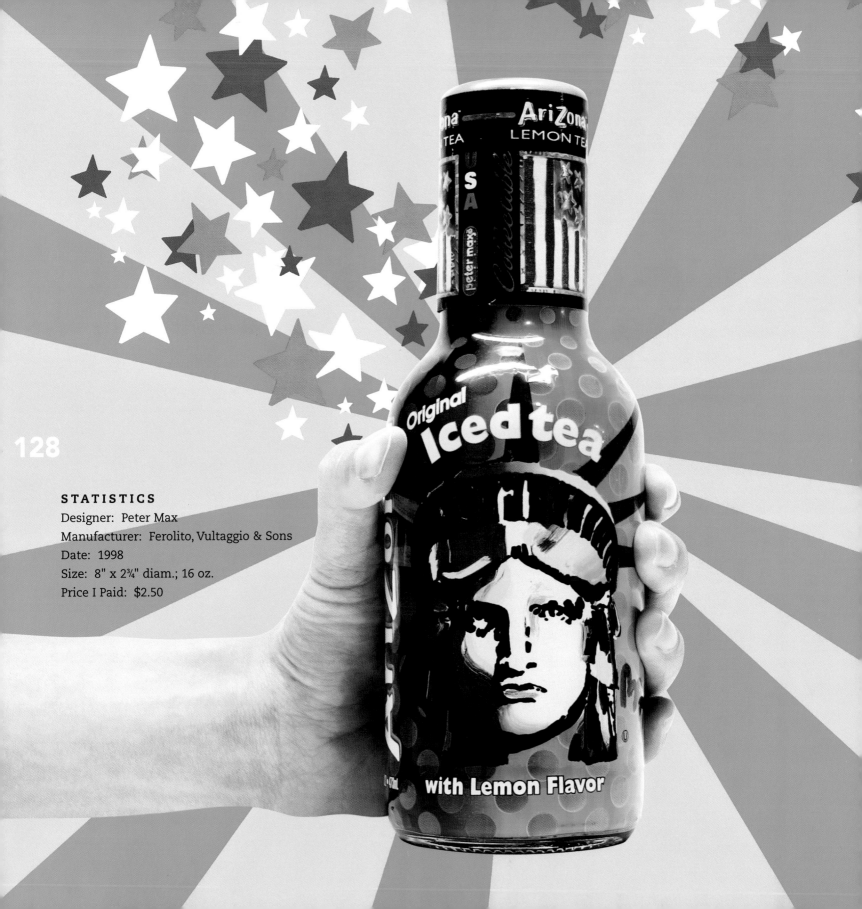

STATISTICS

Designer: Peter Max
Manufacturer: Ferolito, Vultaggio & Sons
Date: 1998
Size: 8" x 2¾" diam.; 16 oz.
Price I Paid: $2.50

Peter Max
AriZona Bottle

A psychedelic Pop artist of the 1960s,

Peter Max became famous for his bold, colorful graphics capturing the energy of rock and roll. During his long and successful career, his work has been featured on television, on numerous magazine covers, and even on a postage stamp. In 1976 he created a book and installation for the bicentennial titled *Peter Max Paints America*. That same year, he started his annual Fourth of July tradition, painting a portrait of the Statue of Liberty.

In 1998 AriZona Beverage Company commissioned Max to produce artwork for their bottles. They were already well known for using innovative packaging to distinguish their products on store shelves. Wanting to push the concept even further, they set out to collaborate with well-known artists, and Max was one of the first. He developed his Statue of Liberty images into the Liberty Series, each bottle bearing his signature imprint and numbered as part of a limited edition.

HOW
do they do that?

(science majors)

Orbitz

THE SODA WITH BALLS!

IT MAY LOOK "OUT OF THIS WORLD," but there is a down-to-earth chemical explanation for the gravity-defying balls that float in the Orbitz soda bottle.

The density of the balls is similar to the density of the liquid, allowing them to float. One ingredient, Xathan gum, keeps the balls evenly dispersed. Another ingredient, Gellan gum, holds them in place by creating an invisible "spider web" support system. No matter how much the bottle is shaken, the balls return to a suspended state.

Drinking it is another matter—the soda's taste never reached "orbit" with consumers. But the package design got high ratings for its entertainment value, and in 1996 it won both the Clear Choice Packaging Award and the Mobius Packaging Award.

Orbitz soda is no longer in production.

STATISTICS
Designer: Karacters Design Group
Manufacturer: Clearly Canadian
Date: 1996
Size: 7" x 2½" diam.; 300 mL
Price I Paid: $2.50 / 6 bottles

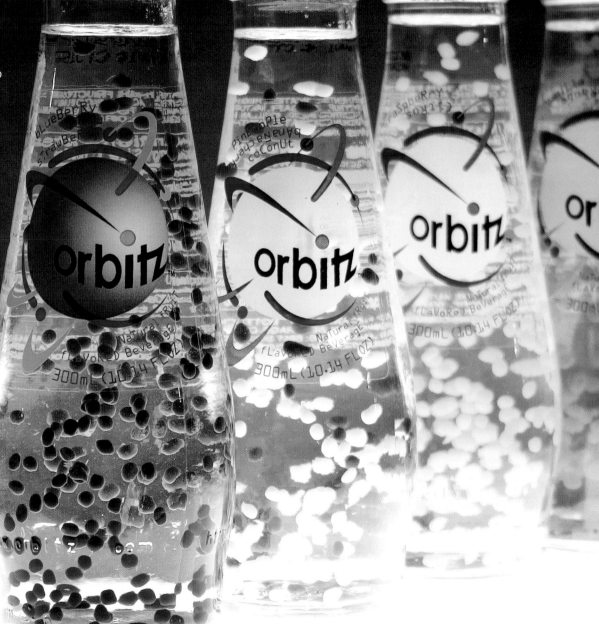

B.L.O.

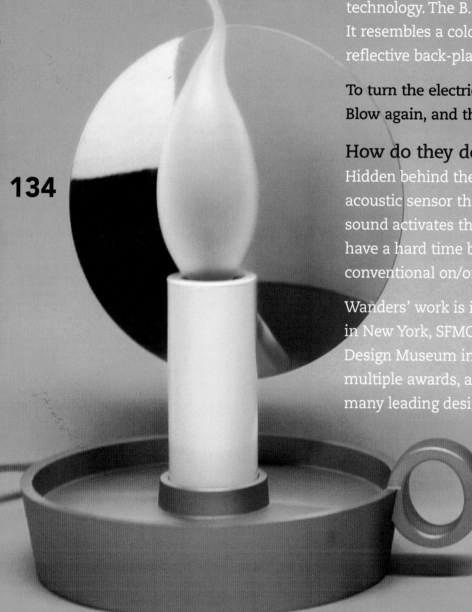

Marcel Wanders is one of the most inventive designers working today. A trademark of his work is the juxtaposition of historical references with modern technology. The B.L.O. lamp is a prime example. It resembles a colonial candlestick, complete with reflective back-plate.

To turn the electric light on, you blow on the "candle." Blow again, and the light turns off.

How do they do that?

Hidden behind the candle, in the reflective plate, is an acoustic sensor that responds to noise. The blowing sound activates this sensor. Of course, for people who have a hard time blowing, there is also the more conventional on/off switch.

Wanders' work is in the permanent collections of MoMA in New York, SFMOMA in San Francisco, and the Vitra Design Museum in Germany, among others. He has won multiple awards, and his products have appeared in many leading design magazines.

STATISTICS
Designer: Marcel Wanders
Manufacturer: Flos
Date: 2001
Size: 7½" x 5" diam.
Price I Paid: $145

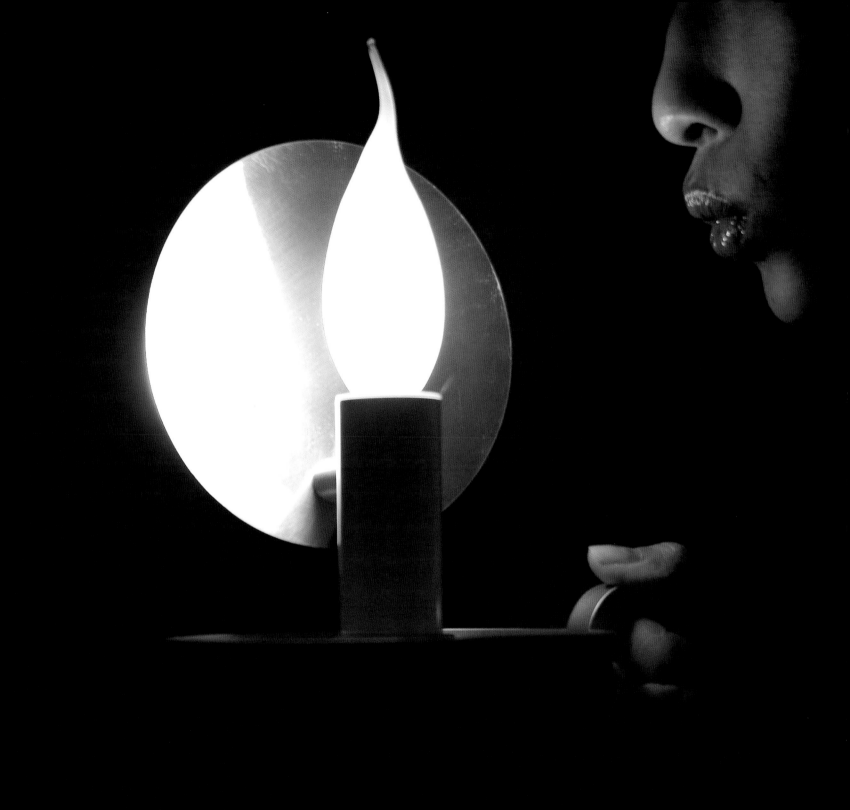

Egg Vase

With fertile creativity, Marcel Wanders came up with this outrageous vase. Its unique shape is created from a latex condom holding hard-boiled eggs. The vase is quite elegant in its design details and construction. The exterior has a matte finish of unglazed white porcelain, while the interior has a waterproof, clear shiny glaze.

136

PUBLISHED

Metropolis, February 2003

I.D., March/April 2000

Business Week, June 17, 2002

EXHIBITED

Cooper-Hewitt National Design Museum, 2002

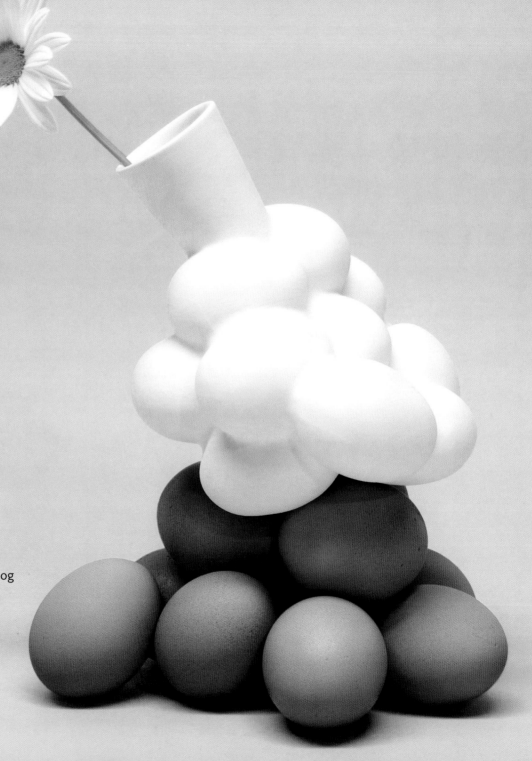

137

STATISTICS

Designer: Marcel Wanders for Droog
Design
Manufacturer: Moooi
Date: 1997
Size: 5½" x 4½" diam.
Price I Paid: $135

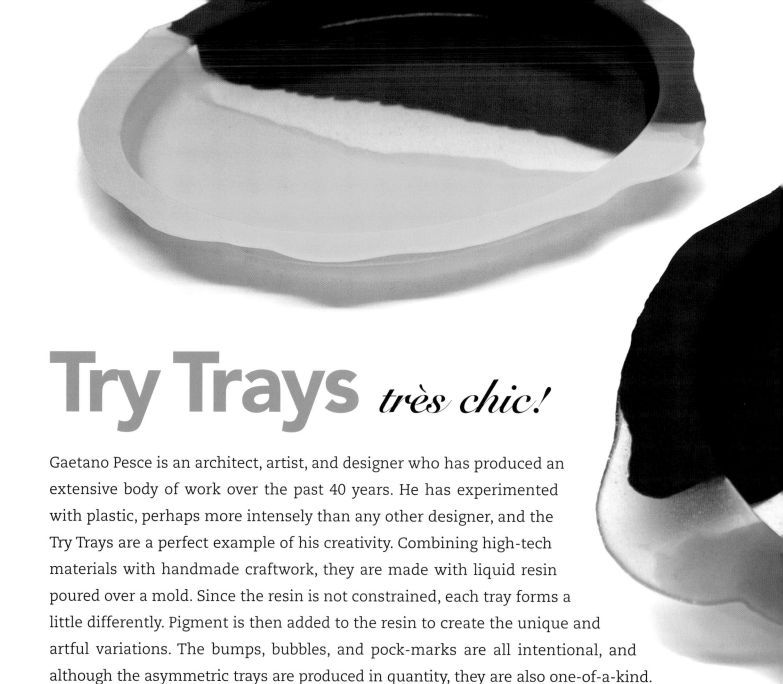

Try Trays *très chic!*

Gaetano Pesce is an architect, artist, and designer who has produced an extensive body of work over the past 40 years. He has experimented with plastic, perhaps more intensely than any other designer, and the Try Trays are a perfect example of his creativity. Combining high-tech materials with handmade craftwork, they are made with liquid resin poured over a mold. Since the resin is not constrained, each tray forms a little differently. Pigment is then added to the resin to create the unique and artful variations. The bumps, bubbles, and pock-marks are all intentional, and although the asymmetric trays are produced in quantity, they are also one-of-a-kind.

Pesce's work is exhibited all over the world. Many of his eccentric products are priced as fine art rather than as household objects. These trays, retailing at $475, are relatively affordable compared with many of his other pieces. A multi-award-winning designer, Pesce was honored with Collab's 2005 Design Excellence Award at the Philadelphia Museum of Art.

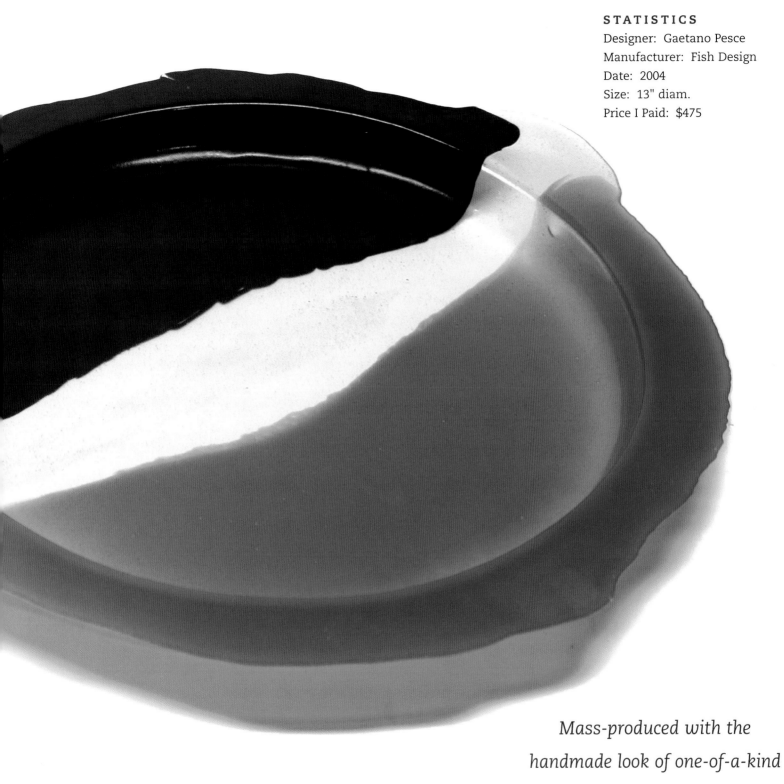

STATISTICS
Designer: Gaetano Pesce
Manufacturer: Fish Design
Date: 2004
Size: 13" diam.
Price I Paid: $475

Mass-produced with the

handmade look of one-of-a-kind

Incredible!

Weighing less than three pounds,
this chair can hold an adult comfortably.

140

Knotted Chair

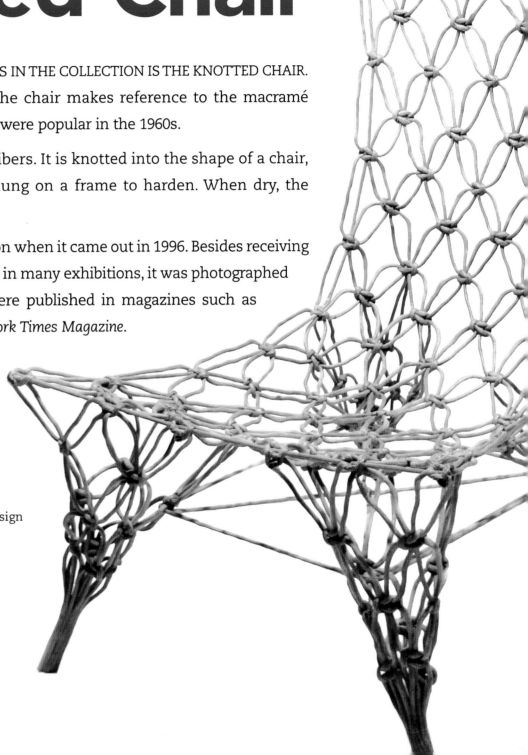

ONE OF THE MOST NOTABLE PIECES IN THE COLLECTION IS THE KNOTTED CHAIR. Designed by Marcel Wanders, the chair makes reference to the macramé (knotted rope) plant holders that were popular in the 1960s.

The rope is made of high-tech fibers. It is knotted into the shape of a chair, dipped into epoxy resin, and hung on a frame to harden. When dry, the chair has strength and rigidity.

The Knotted Chair was a sensation when it came out in 1996. Besides receiving numerous awards and appearing in many exhibitions, it was photographed in contemporary homes that were published in magazines such as *Metropolitan Home* and *The New York Times Magazine*.

STATISTICS
Designer: Marcel Wanders for Droog Design
Manufacturer: Cappellini
Date: 1995
Size: 28" x 19¾" x 24½"
Cost: $2,200

Won't Break the bank

for the thrifty collector

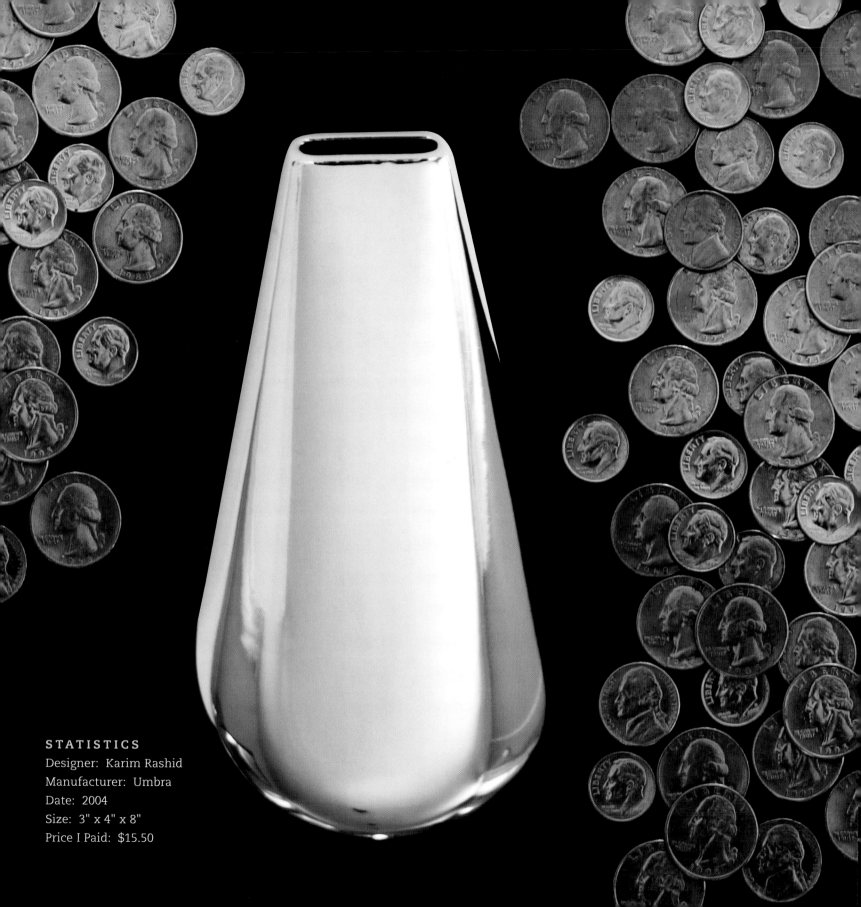

STATISTICS
Designer: Karim Rashid
Manufacturer: Umbra
Date: 2004
Size: 3" x 4" x 8"
Price I Paid: $15.50

Volcoino

A non-piggy piggy bank

Many designers bring humor to serious or mundane products. With Volcoino, Karim Rashid has gone in the other direction. He has taken a serious approach to something that is usually cute.

Forgoing the traditional "piggy," he approached the design as he would a work of art, creating an elegant, abstract sculpture. It could easily be found in a museum of modern art.

It looks like silver or stainless steel but is, in fact, chrome-plated ceramic.

Volcoino works as a functional object as well as a beautiful design; and at $15.50, it won't break the bank.

Designer: Unknown
Manufacturer: Mahakit Rubber Co. Ltd
Date: 1995
Size: assorted sizes
Price I Paid: $5 / set of 16

Rubber X-Bands

Permanent Collection: The Museum of Modern Art, New York

Featured in the Museum of Modern Art's 2004 exhibition "Humble Masterpieces," this redesigned rubber band uses the simplest of innovations. The bands are criss-crossed into an X-shape, giving greater stability and security in two directions. It solves the problem of holding together a large stack of things like cards or discs that often slip out. And it can be used as a single or double band, giving it even more flexibility.

147

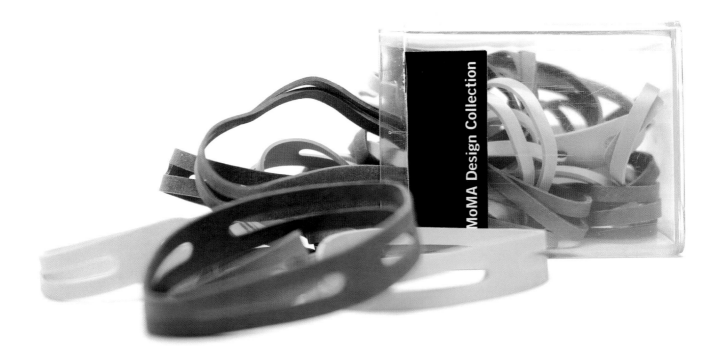

Creating a new counter culture!

Method Dish Soap

A soap bottle had never been the focus of a major designer until Karim Rashid was approached by Method, a young manufacturing company that wanted to use design to distinguish its containers in the marketplace. The company hoped that because of the design, people would buy them and *want* to leave them out on the counter.

Rashid was perfect for this assignment. With his plastic products known as "blobjects," he was already a champion of disposable design. The dish soap bottle uses a shape that is part of his design vocabulary—it shows up as the pawn on his chess set. Squeeze the bottle in the middle and the soap comes out of the bottom. Release the pressure and the opening closes back up, keeping the soap from dripping out.

This bottle has brought tremendous attention to the company.

It has been published in many magazines, including

New York, Lucky, Home, Metropolitan Home, Dwell, and *Food & Wine.*

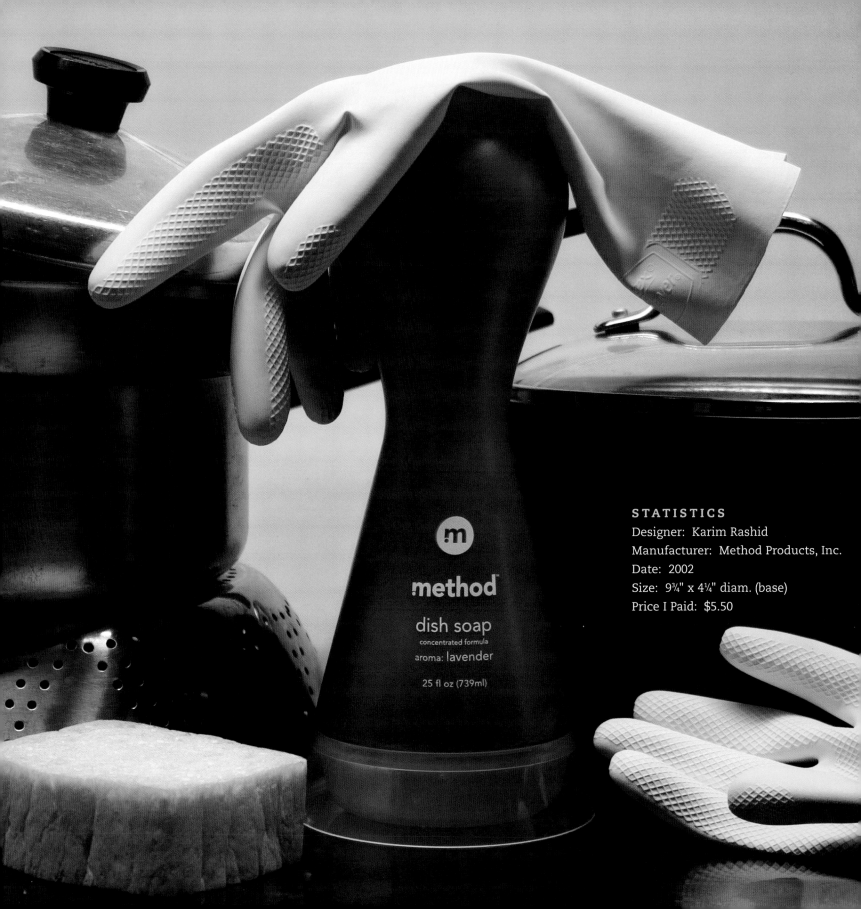

m

method

dish soap
concentrated formula
aroma: lavender

25 fl oz (739ml)

STATISTICS

Designer: Karim Rashid
Manufacturer: Method Products, Inc.
Date: 2002
Size: 9¾" x 4¼" diam. (base)
Price I Paid: $5.50

150

Staple Clock

URING THE RECESSION IN THE EARLY 1990S, many manufacturers had to trim back their production costs. Elika, a small clock company, asked its designers to come up with a product that could sell for under $15 yet still be original. Constantin Boym took up the challenge and created the Staple Clock. It was made of twelve staples and cardboard (plus the clock mechanism). Each staple was attached by hand with a special template. The clock was economical, recyclable, and easy to make while still exhibiting an elegant and contemporary design.

The clock caught the attention of New York's Museum of Modern Art, where it was featured in the 1995 exhibition "Mutant Materials in Modern Design."

STATISTICS
Designer: Constantin Boym
Manufacturer: Elika
Size: 9" x 8"
Date: 1993
Price I Paid: $12.50

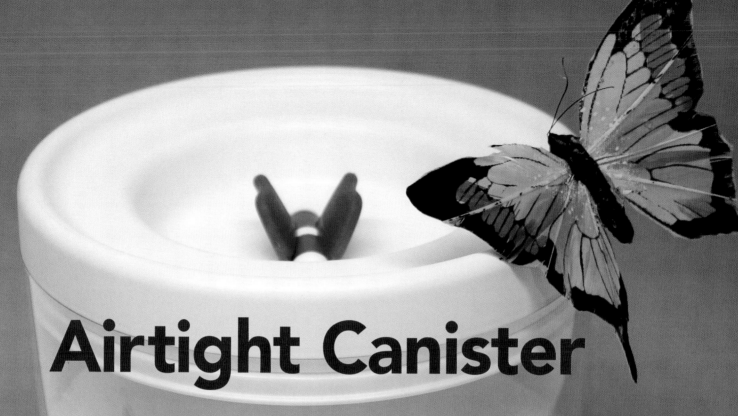

Airtight Canister

MICHAEL GRAVES ADDS HIS SIGNATURE STYLE to this ingenious airtight kitchen canister for Target. His trademark blue shows up on the butterfly-like toggle, which personalizes the canister for this collection. The technology of the container is quite clever. The top is easily removed by squeezing the toggle with one hand. When the lid is replaced, it remains so tightly sealed that even a loaded container can be lifted by the toggle alone.

STATISTICS
Designer: Michael Graves
Manufacturer: Click Clack Limited for Target
Date: 1999
Size: 8" x 7" diam.
Price I Paid: $12

Ty-Nant
Water Bottle

Ty-Nant believes in the power of design. They believe in it so much that they gave their designer, Ross Lovegrove, the freedom to create a bottle like none other on the market.

Lovegrove was already a prolific and independent-minded industrial designer who had worked for such clients as Louis Vuitton, Hermès, Apple Computers, Knoll, Mazda, and Pottery Barn. He brought the same level of creativity he used for these more extravagant projects to Ty-Nant's water bottle.

His design is nothing short of remarkable. It took a manufacturing tour de force to create the bottle's asymmetrical form. The shape resembles moving water or melting ice, a clever reference to the bottle's content. Its sculpted surface reflects light from all directions and causes it to glisten on the shelf. The nooks and crannies keep it from slipping out of the hand and give the bottle a comfortable grip.

The bottle design was a big success, selling millions of units since its launch in 2001. It went on to win a multitude of awards.

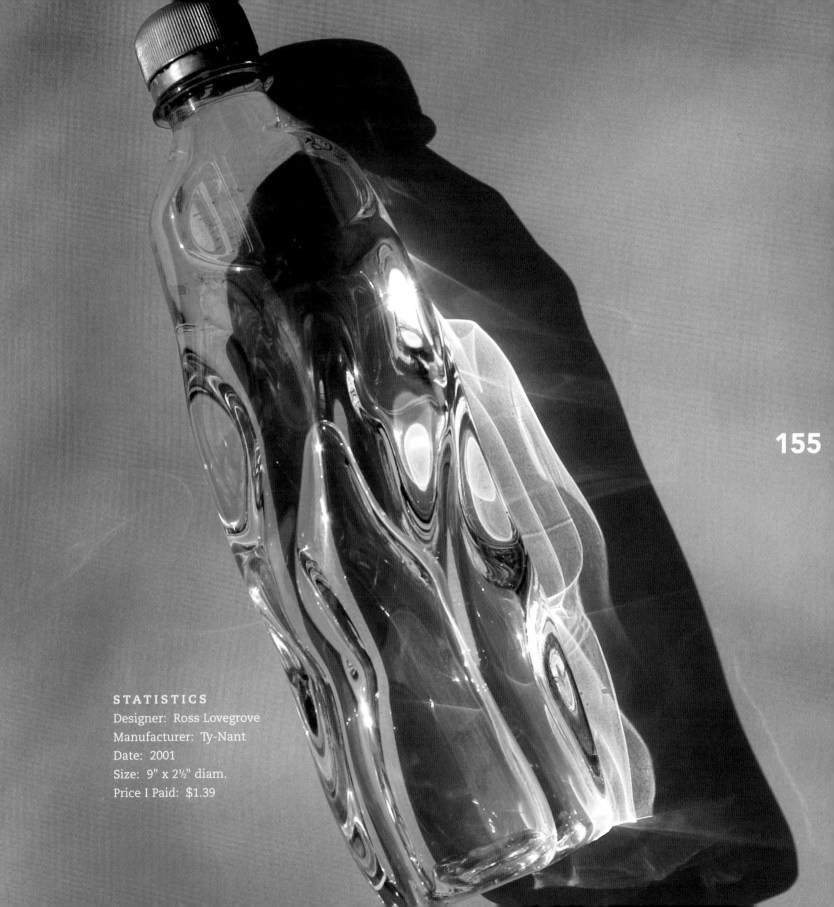

155

STATISTICS
Designer: Ross Lovegrove
Manufacturer: Ty-Nant
Date: 2001
Size: 9" x 2½" diam.
Price I Paid: $1.39

PRICES THAT'LL BLOW YOUR MIND

($$$)

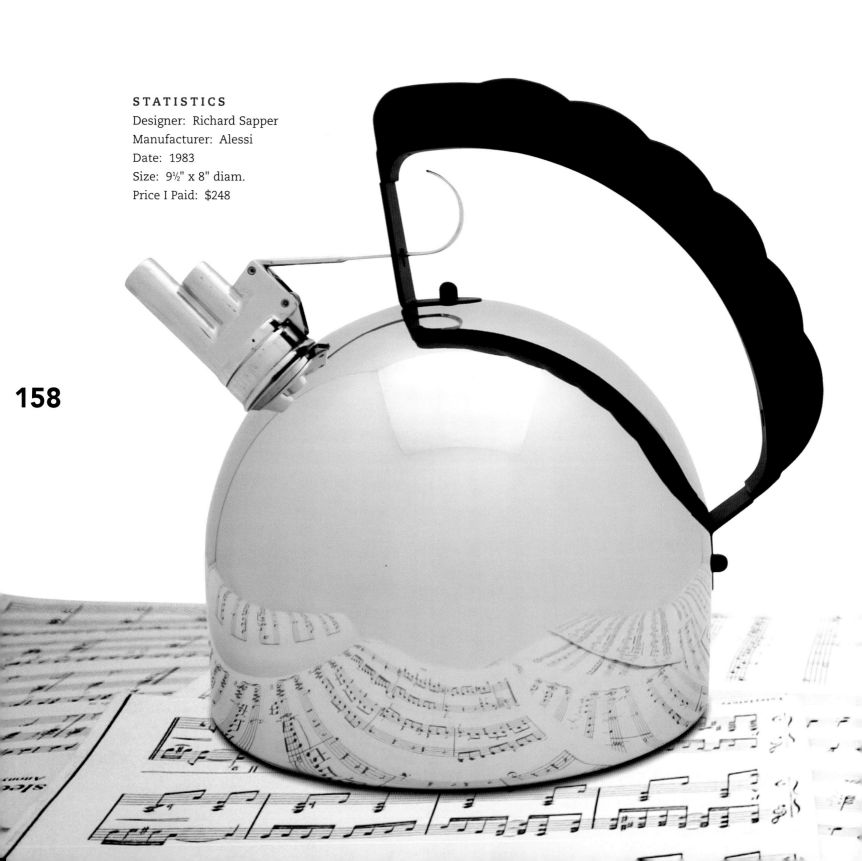

STATISTICS
Designer: Richard Sapper
Manufacturer: Alessi
Date: 1983
Size: 9½" x 8" diam.
Price I Paid: $248

158

Melodic Water Kettle

There have been many "designer kettles" introduced over the past 25 years, but this was the first produced by Alessi. The kettle's designer, Richard Sapper, was an engineer whose clients included Mercedes-Benz, Fiat, IBM, and Knoll International. He approached the redesign of the basic tea kettle with the same sophistication he used in engineering these more complex projects.

His kettle is one of the most expensive on the market, retailing for over $200. It is made with brass, copper, stainless steel, and high-performance plastic-polyamide, and its most distinguishing and appealing characteristic is its brass harmonica-style whistle. When the steam comes through, it plays two musical notes (E and B), creating a unique and pleasingly melodic sound.

Sapper's products have won the Compasso d'Oro Prize—Italy's most prestigious industrial design award—many times, and they are exhibited in permanent museum collections worldwide.

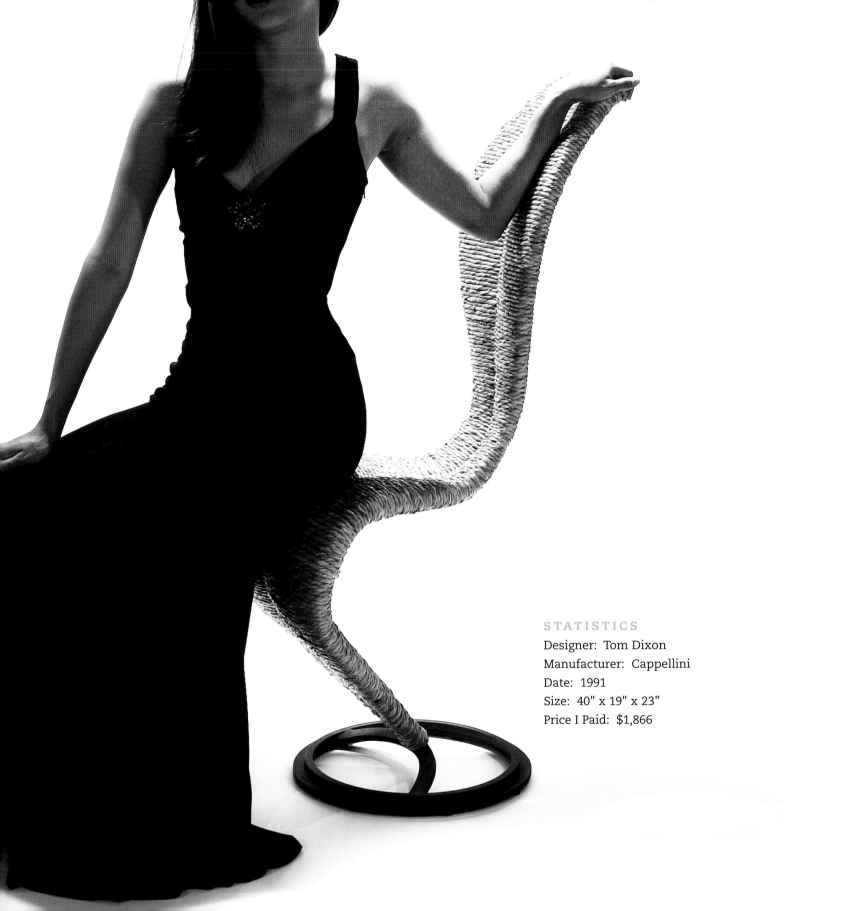

STATISTICS

Designer: Tom Dixon
Manufacturer: Cappellini
Date: 1991
Size: 40" x 19" x 23"
Price I Paid: $1,866

How do you create a new chair that looks like no other? Tom Dixon answered this question with the S Chair. A self-trained designer with welding skills acquired from maintaining his motorcycle, Dixon created 50 prototypes before coming up with this elegant and sinewy shape. It is made of a bent steel frame that is all spine and no legs. The chair is available in a variety of materials; this one is made of woven marsh straw.

Dixon worked with the well-known Italian furniture company Cappellini to mass-produce and distribute the chair in 1989. It achieved great success and is now highly recognized as representative of modern furniture design for the late 20th century.

Since 2001, Dixon has been the creative director for Habitat, the British home-furnishing retail chain. In addition, he runs his own design studio, creating furniture and housewares. Always looking to apply his ideas to new products, he even designs sex toys… but that is for another book.

161

S Chair

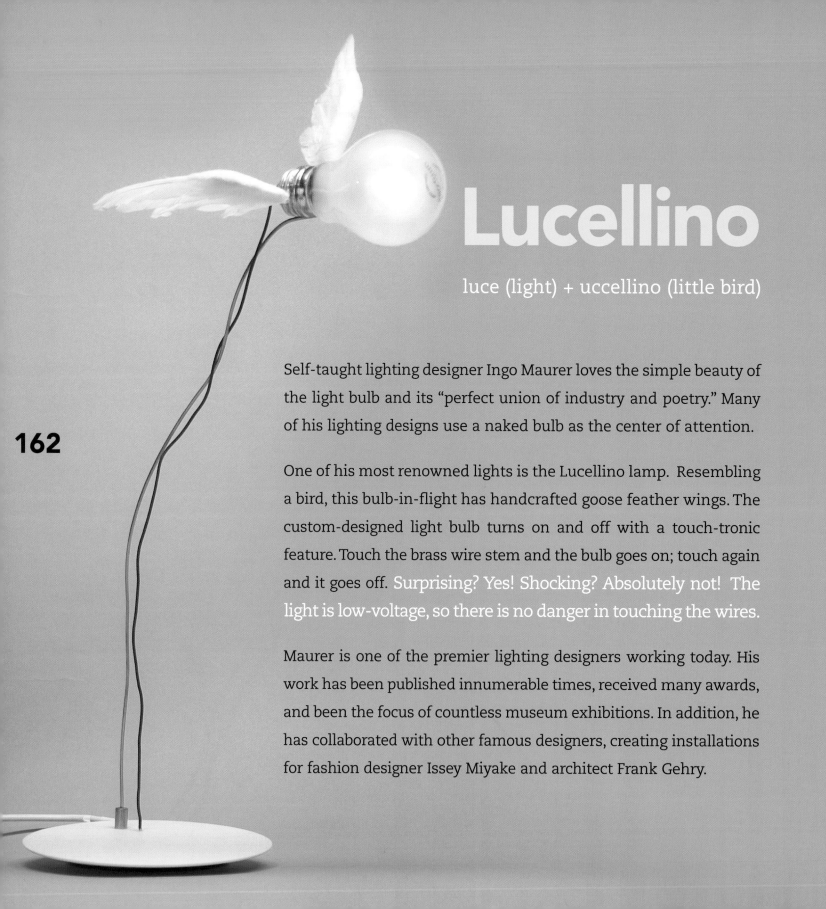

Lucellino

luce (light) + uccellino (little bird)

Self-taught lighting designer Ingo Maurer loves the simple beauty of the light bulb and its "perfect union of industry and poetry." Many of his lighting designs use a naked bulb as the center of attention.

One of his most renowned lights is the Lucellino lamp. Resembling a bird, this bulb-in-flight has handcrafted goose feather wings. The custom-designed light bulb turns on and off with a touch-tronic feature. Touch the brass wire stem and the bulb goes on; touch again and it goes off. Surprising? Yes! Shocking? Absolutely not! The light is low-voltage, so there is no danger in touching the wires.

Maurer is one of the premier lighting designers working today. His work has been published innumerable times, received many awards, and been the focus of countless museum exhibitions. In addition, he has collaborated with other famous designers, creating installations for fashion designer Issey Miyake and architect Frank Gehry.

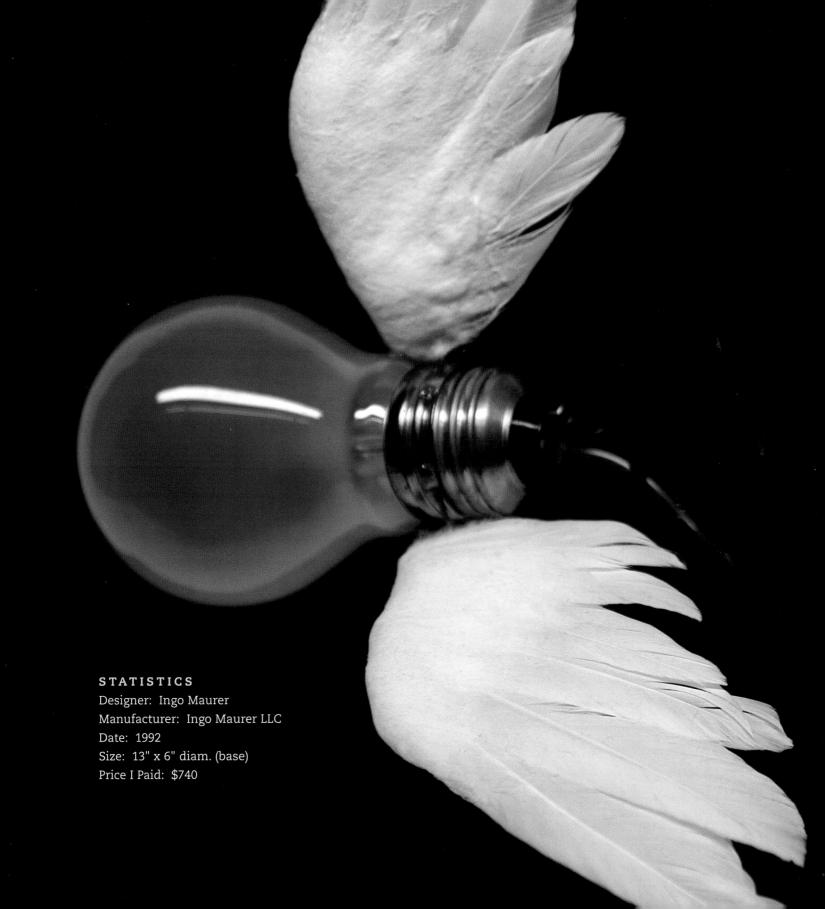

STATISTICS
Designer: Ingo Maurer
Manufacturer: Ingo Maurer LLC
Date: 1992
Size: 13" x 6" diam. (base)
Price I Paid: $740

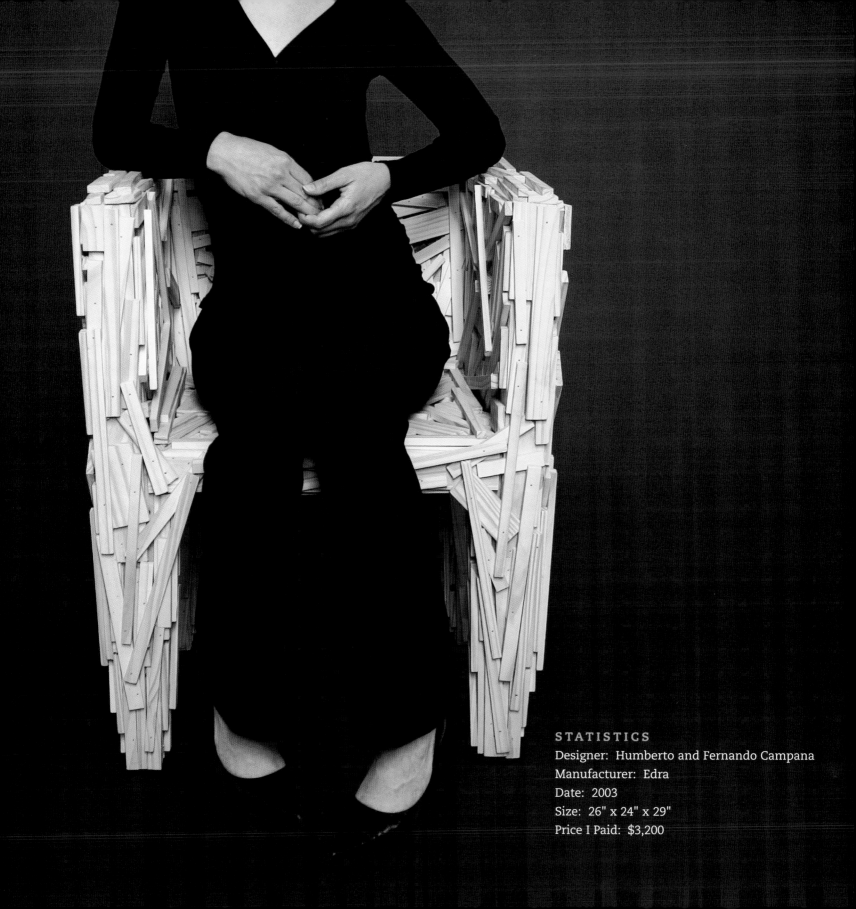

STATISTICS
Designer: Humberto and Fernando Campana
Manufacturer: Edra
Date: 2003
Size: 26" x 24" x 29"
Price I Paid: $3,200

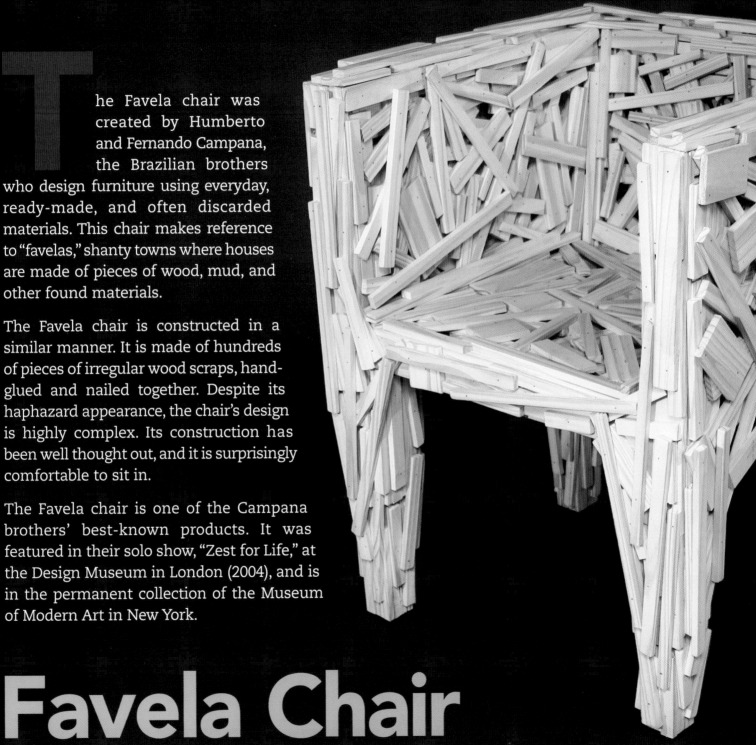

The Favela chair was created by Humberto and Fernando Campana, the Brazilian brothers who design furniture using everyday, ready-made, and often discarded materials. This chair makes reference to "favelas," shanty towns where houses are made of pieces of wood, mud, and other found materials.

The Favela chair is constructed in a similar manner. It is made of hundreds of pieces of irregular wood scraps, hand-glued and nailed together. Despite its haphazard appearance, the chair's design is highly complex. Its construction has been well thought out, and it is surprisingly comfortable to sit in.

The Favela chair is one of the Campana brothers' best-known products. It was featured in their solo show, "Zest for Life," at the Design Museum in London (2004), and is in the permanent collection of the Museum of Modern Art in New York.

Favela Chair

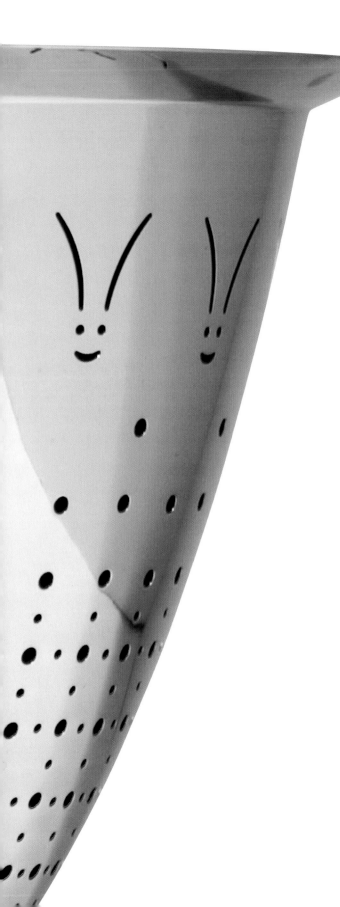

Max le Chinois

Philippe Starck transformed a utilitarian colander into an art object by making its shape twice the height of a standard colander, using high-quality stainless steel and brass, and embellishing the sides with the whimsical face of Max le Chinois. Of course, this transformed the price as well ($328!).

Yet Max is also quite practical. Unlike other colanders, it comes with a plastic liner, which allows it to be used in many ways, such as a vase, fruit bowl, ice bucket, or plant pot. Most notably, it looks stylish just sitting on the counter doing nothing.

This colander is one of Starck's signature pieces. Without a doubt, he has elevated functional objects to the status of "works of art."

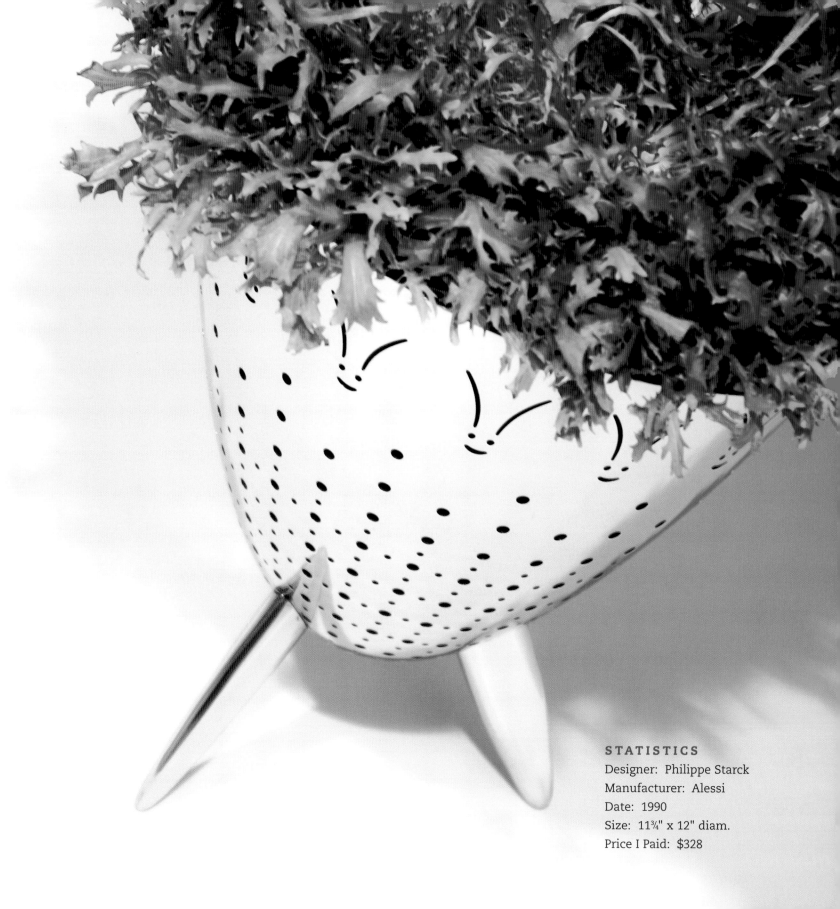

STATISTICS
Designer: Philippe Starck
Manufacturer: Alessi
Date: 1990
Size: 11¾" x 12" diam.
Price I Paid: $328

Eudora

Inspired by the armchairs of the 1930s,

the Eudora chair combines historic references with modern technology. It is made of fiberglass, "upholstered" in the fabric of your choice, and then encased in resin. The chair is strong, surprisingly comfortable, and great for lounging. Fluorescent lights hidden inside the chair give it a surrealistic glow. The lights can be left on all day and the chair never gets hot.

Eudora was chosen for the 2003 Cooper-Hewitt National Design Museum's Design Triennial Exhibition, "Inside Design Now." It has been featured on HGTV and NBC's *Today Show*; in *Metropolitan Home* and *Art in America*; and in the windows of New York's Saks Fifth Avenue.

STATISTICS
Designer: Critz Campbell
Manufacturer: b9 design
Date: 2001
Size: 32" x 32" x 39"
Price I Paid: $2,800

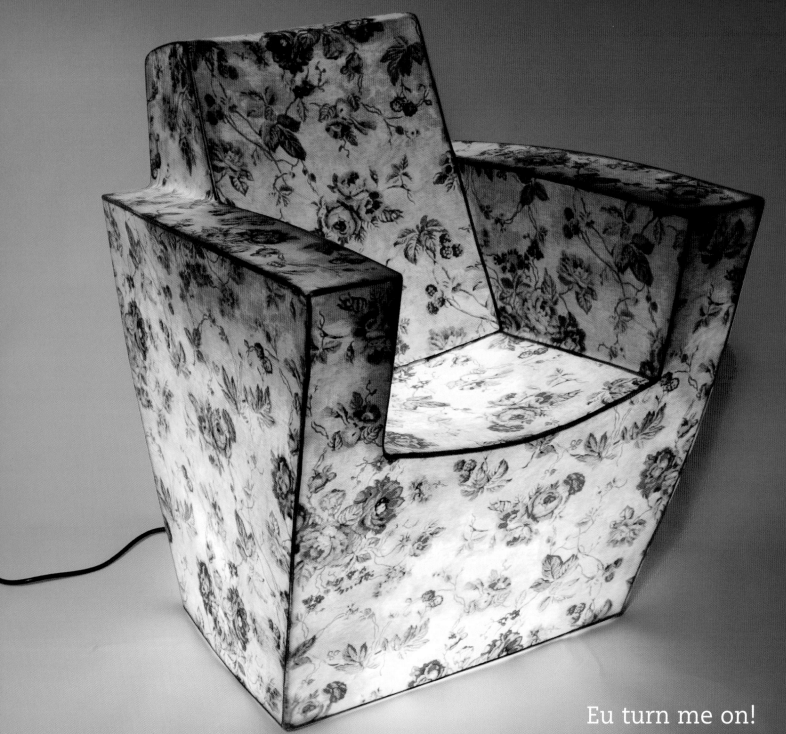

Eu turn me on!

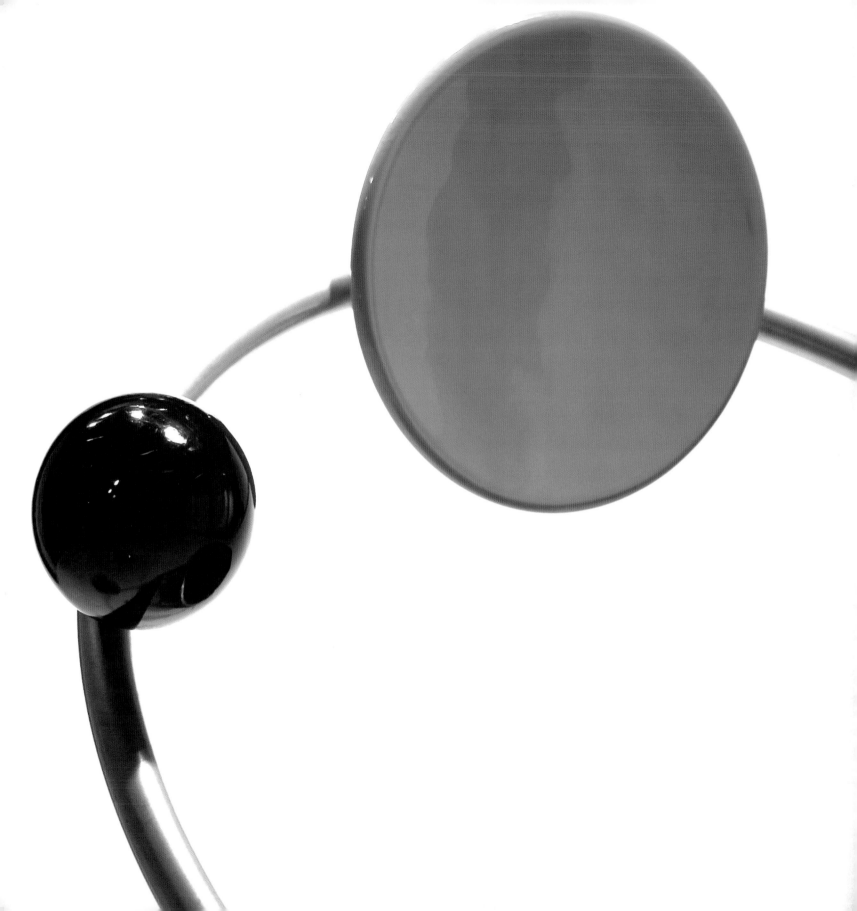

The FUTURE IS NOW

(today's market value)

First Chair

...not the second

The Memphis design movement, which started in Milan, Italy, in 1981, was a radical group of mostly Italian architects who wanted to transform the design industry. They broke away from confining "less is more" modernism and brought wild and crazy designs to furniture, ceramics, glassware, and textiles. The First chair was one of the designs that became emblematic of this movement. Designed by Michele De Lucchi, the chair is made of a tubular steel frame and brightly painted wood circles and balls. The chair looks more like a solar system model than a seating unit, and it is not particularly comfortable. Yet it has become an icon of Memphis design. Almost every book, article, and museum collection on this design group includes one of these chairs.

The chair is still in production, but the price has more than doubled!

173

STATISTICS

Designer: Michele De Lucchi
Manufacturer: Memphis Milano
Date: 1983
Size: 35" x 26" x 15½"
Price I Paid: $365 (1983)
Now: $850

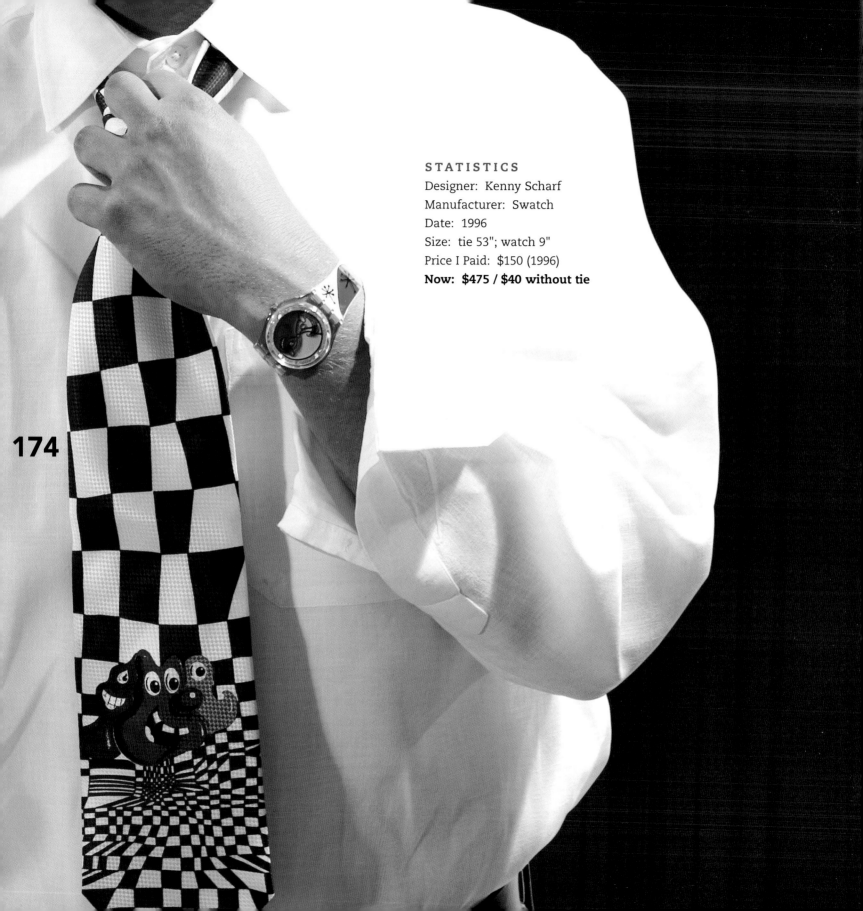

174

STATISTICS
Designer: Kenny Scharf
Manufacturer: Swatch
Date: 1996
Size: tie 53"; watch 9"
Price I Paid: $150 (1996)
Now: $475 / $40 without tie

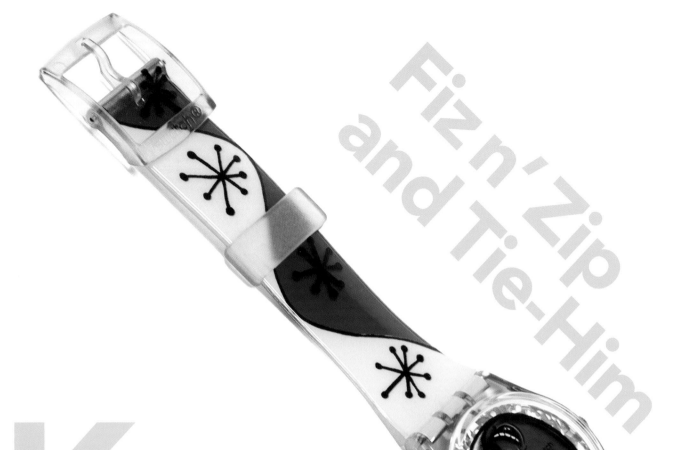

K Kenny Scharf entered the art scene in the 1980s with his style of "pop surrealism." Influenced by TV and popular culture, his distinctive cartoon imagery garnered him immediate recognition and success. Museums and collectors bought his paintings, and major companies like Absolut Vodka and the Cartoon Network used his artwork in marketing campaigns.

In the midst of his tremendous popularity, Scharf was asked by Swatch to design a watch as part of their artist series. His design, called Fiz n' Zip, played off a yin/yang symbol. In addition to the watch, he also created a coordinated necktie, Tie-Him. **Sold individually or as a set, the tie now gives the watch its increased value.**

Cross Check Arm Chair

Frank Gehry is the architect of the famous Guggenheim Museum in Bilbao, Spain, and winner of architecture's most prestigious award, the Pritzker Prize. He also designs furniture. His innovative bentwood furniture collection for Knoll was created after several years of experimenting with a new approach to material and structure.

Inspired by the construction of apple crates, Gehry took thin strips of laminated maple, bending and weaving them into sturdy yet lightweight forms. The gem of the bentwood collection, the one that is most frequently published and found in museums, is the Cross Check Arm Chair. Each chair has Gehry's signature and date of production—this particular chair, an early production piece, is dated 10.24.93. The chair has won many awards, including *Time* magazine's Best of Design Award in 1992.

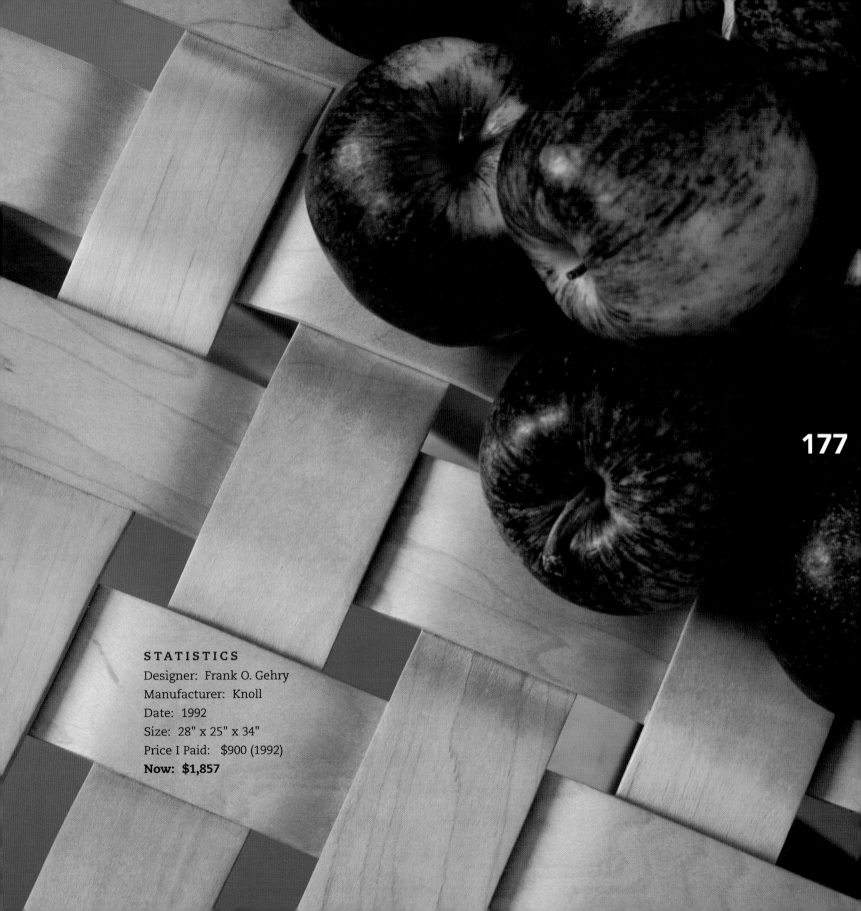

STATISTICS

Designer: Frank O. Gehry
Manufacturer: Knoll
Date: 1992
Size: 28" x 25" x 34"
Price I Paid: $900 (1992)
Now: $1,857

"It's one of the things I'm most ashamed of."

PHILIPPE STARCK

from the catalog of his 2003 exhibition at the Centre Pompidou

NOT!

Hot Bertaa

178

Designers often experiment with new ideas and new materials. Some of these work and others do not. This is the case with the Hot Bertaa tea kettle designed by Philippe Starck. It was one of the first products he created for the manufacturer Alessi. There were already a number of successful kettles in the line, so Starck's had to offer something new. The result was a kettle that was more about style than function; it looked great, but it never worked very well. This didn't stop design lovers and museums from collecting it as an important design of its time.

Out of production since 1997,
the kettle is now an "antique of the future."

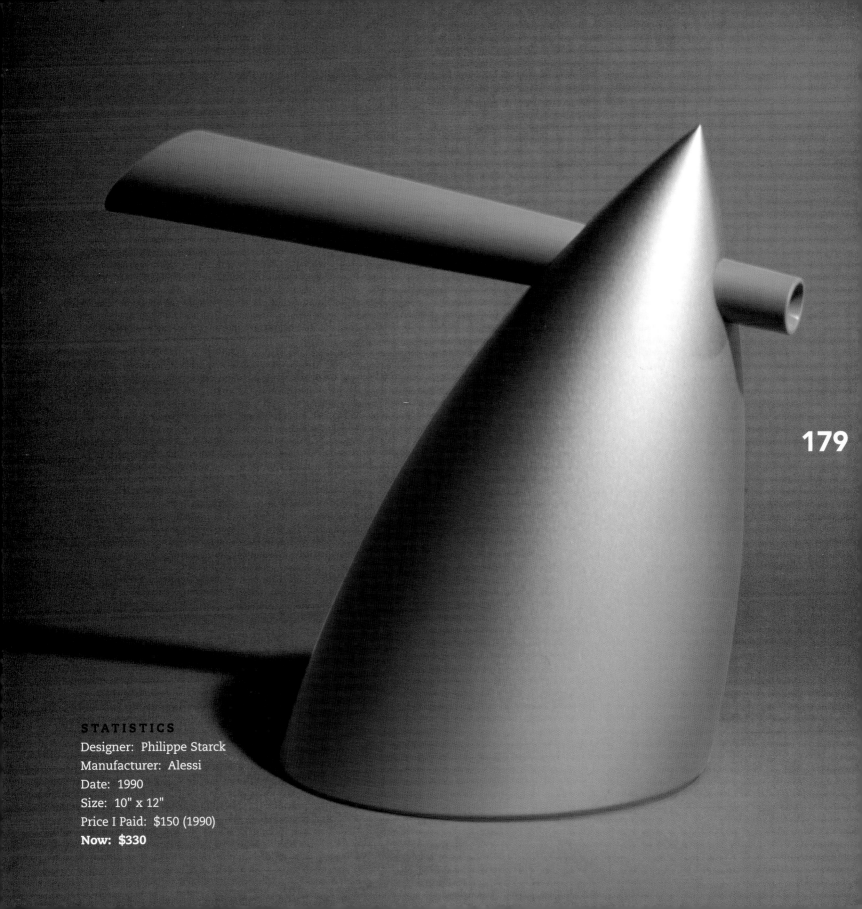

179

STATISTICS
Designer: Philippe Starck
Manufacturer: Alessi
Date: 1990
Size: 10" x 12"
Price I Paid: $150 (1990)
Now: $330

RESOURCES

who, what, where + how

Starting a Collection

COLLECTING

- Pick what you like. First your choices will be purely emotional, but later they will become more informed.
- Create guidelines for your collection so that it has a focus and a point of view.
- Every collection takes on the personality of the collector, so understand your own taste.
- Do your homework: read magazines, go to exhibitions, surf the web.
- Use the Resources section in this book to find the products and learn about them.
- Learn which products are in permanent museum collections, receiving awards, or getting press.
- Having done the research, be confident in making a purchase. Remember that many products are only in the marketplace for a limited time.

PROTECTING

- Preserve your collection—don't use the product. If you like it enough to use it, buy two.
- Keep your collection away from sunlight—materials can fade.
- Keep your collection away from heat and moisture.
- Don't over-handle the objects—hands have oils; hands can drop items.
- If the object is not on display, store it in a dark, cool closet.
- Store objects in marked containers and label them to avoid later rummaging.
- Store books flat and keep magazines and other printed matter in non-acid plastic sleeves.

RECORDING

- Save purchase receipts.
- Save all packaging materials. Hold on to the original box. It will give the products greater value in the future.
- Record product information in a log: designer, manufacturer, date, price, and other noteworthy statistics.
- Keep a file of awards, published articles, books, museum collections, exhibitions, websites, and so on.

An example of a personal journal or log is included on the facing page to get you started on your own **Antiques of the Future** collection.

Product Name	Designer	Manufacturer	Date	Price	Notes
Swivel Peeler SAMPLE	Smart Design	OXO	1989	5.99	MoMA – Permanent Collection

Designers

Marc Berthier
www.eliumstudio.com
Tykho Rubber Radio

Flemming Bo Hansen
www.fbh.dk
Razor and Travel Box

Constantin Boym
www.boym.com
Mona Lisa Clock, Staple Clock

Julian Brown
www.rexite.com
Hannibal

Humberto and Fernando Campana
www.campanadesign.com.br
Favela Chair

Critz Campbell
www.b9furniture.com
Eudora

Sandy Chilewich
www.chilewich.com
RayTRAY

Nick Crosbie
www.inflate.co.uk
Mr. and Mrs. Prickly

Michele De Lucchi
www.amdl.it
First Chair

Tom Dixon
www.tomdixon.net
S Chair

James Dyson
www.dyson.com
Dyson Vacuum Cleaner

Flex Development B.V.
www.flex.nl
Cable Turtle

Naoto Fukasawa, IDEO
www.ideo.com
Muji CD Player

Frank O. Gehry
www.arcspace.com/gehry_new
Cross Check Arm Chair

Stefano Giovannoni
www.stefanogiovannoni.it
Merdolino Toilet Brush, Magic Bunny,
Ship Shape Butter Dish, Lilliput

Michael Graves
www.michaelgraves.com
Whistling Bird Tea Kettle, Toaster for
Target, Airtight Canister

Jonathan Ive, Apple
www.apple.com
iMac G3

Tibor Kalman
www.mairakalman.com/design
Paperweight

Hideo Kanbara
www.kokuyo.co.jp
White Eraser

Karacters Design Group
www.karacters.com
Orbitz

Harri Koskinen
www.friendsofindustry.com
Block Lamp

Neil Kraft and Mary Jo Mitchell
www.kraftworksltd.com
VOSS Water

Annie Leibovitz
www.swatch.com
Swatch for 1996 Atlanta Olympics

Ross Lovegrove
www.rosslovegrove.com
Ty-Nant Water Bottle

Ingo Maurer
www.ingo-maurer.com
Lucellino

Peter Max
www.petermax.com
Peter Max AriZona Bottle

Alessandro Mendini
www.ateliermendini.it
Anna Pepper

Jasper Morrison
www.jaspermorrison.com
Air-Chair

Rudolph Moshammer
www.moshammer.de
Feathers

Takashi Murakami
www.takashimurakami.com
The Flower Ball

Marc Newson
www.marc-newson.com
Hair Dryer

Josh Owen
www.joshowen.com
XOX Table

Frank Person and Jan Hansen
www.fpformgebung.de
DUSTIN Dustpan + Brush

Gaetano Pesce
www.gaetanopesce.com
Try Trays

Robin Platt & Cairn Young
www.koziol.de
TOQ Toilet Brush

Karim Rashid
www.karimrashid.com
Kissing Salt and Pepper Shakers, Garbo,
Chess Set, Volcoino, Method Dish Soap

Niki de Saint Phalle
www.nikidesaintphalle.com
Niki de Saint Phalle Snake

Richard Sapper
www.richardsapper.com
Melodic Water Kettle

Kenny Scharf
www.kennyscharf.com
Fiz n' Zip and Tie-Him

Jerszy Seymour
www.jerszyseymour.com
Pipe Dreams

Smart Design
www.smartdesignusa.com
WOVO Thermal Carafe, OXO Products

Philippe Starck
www.philippe-starck.com
Excalibur Toilet Brush, Poaa Hand Weights,
Mister Meumeu, Liberté, Dr. Skud, Dr. Kiss,
Juicy Salif, Max le Chinois, Hot Bertaa

Swatch
www.swatch.com
Skeleton Loomi

Robert Venturi
www.vsba.com
Necktie with Grandmother Pattern

Matti Walker
www.stadlerform.ch
Max Heater

Marcel Wanders
www.marcelwanders.com
B.L.O., Egg Vase, Knotted Chair

Zetsche + Heckhausen
www.elmarfloetotto.de
Flower Power

185

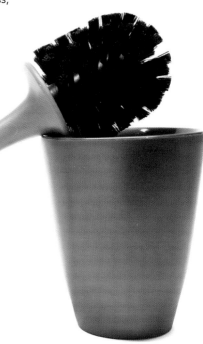

Manufacturers

Alessi
www.alessi.com
Mister Meumeu, Liberté, Merdolino
Toilet Brush, Anna Pepper, Whistling Bird
Tea Kettle, Dr. Skud, Dr. Kiss, Magic Bunny,
Ship Shape Butter Dish, Lilliput, Juicy Salif,
Melodic Water Kettle,
Max le Chinois, Hot Bertaa

Apple
www.apple.com
iMac G3

b9 design
www.b9furniture.com
Eudora

Bozart (now Cerealart)
www.cerealart.com
XOX Table, Karim Rashid Chess Set,
The Flower Ball

Cappellini
www.cappellini.it
Knotted Chair, S Chair

Chilewich
www.chilewich.com
RayTRAY

Clearly Canadian
www.clearly.ca
Orbitz

Cleverline
www.cleverline.nl
Cable Turtle

Dyson, Ltd.
www.dyson.co.uk
Dyson Vacuum Cleaner

Edra
www.edra.com
Favela Chair

Elika
(no longer in business)
Staple Clock, Mona Lisa Clock

Elmarflötotto
www.elmarfloetotto.de
Flower Power

Fabric Workshop and Museum
www.fabricworkshop.org
Necktie with Grandmother Pattern

Ferolito, Vultaggio & Sons
www.arizonabev.com
Peter Max AriZona Bottle

Fish Design
www.fish-design.it
Try Trays

Flos
www.flos.com
B.L.O.

Heller
www.helleronline.com
Excalibur Toilet Brush

Inflate
www.inflate.co.uk
Mr. and Mrs. Prickly

Ingo Maurer LLC
www.ingo-maurer.com
Lucellino

Knoll
www.knoll.com
Cross Check Arm Chair

Kokuyo Co., Ltd.
www.kokuyo.co.jp
White Eraser

Koziol
www.koziol.de
DUSTIN Dustpan + Brush, TOQ Toilet
Brush

Lexon
www.lexon-design.com
Tykho Rubber Radio

M&Co.
www.mairakalman.com/design
Paperweight

Magis
www.magisdesign.com
Air-Chair, Pipe Dreams

Memphis Milano
www.memphis-milano.com
First Chair

Method Products, Inc.
www.methodhome.com
Method Dish Soap

Moooi
www.moooi.com
Egg Vase

Muji
www.mujionline.com
Muji CD Player

The Museum of Modern Art
www.moma.org
Block Lamp, Rubber X-Bands

Nambé
www.nambe.com
Kissing Salt and Pepper Shakers

OXO, International
www.oxo.com
Good Grips Products

Productions Flammarion 4
www.jnfprod.com
Niki de Saint Phalle Snake

Rexite
www.rexite.com
Hannibal

Rosendahl
www.rosendahl.com
Razor and Travel Box

Stadler Form
www.stadlerform.ch
Max Heater

Swatch
www.swatch.com
Skeleton Loomi, Feathers, Swatch for 1996
Atlanta Olympics, Fiz n' Zip and Tie-Him

Target
www.target.com
Toaster for Target, Airtight Canister

Ty-Nant
www.tynant.com
Ty-Nant Water Bottle

Umbra
www.umbra.com
Garbo, Volcoino

Vidal Sassoon
www.vidalsassoon.com
Marc Newson Hair Dryer

Voss
www.vosswater.com
VOSS Water

WOVO
www.wilton.com
WOVO Thermal Carafe

XO
www.xo-design.com
Poaa Hand Weights

187

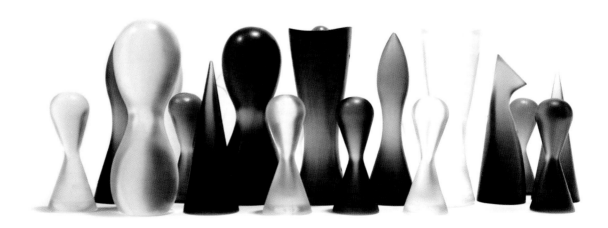

Where to shop

Abe Books
www.abebooks.com
Largest online marketplace for new, used, rare, and out-of-print books.

Amazon
www.amazon.com
Resource for almost everything.

Arango
www.arango-design.com
Dadeland Mall
7519 SW 88th Street
Miami, FL 33156
Tel: 305.661.4229
Contemporary home and office accessories.

Centro Modern Furnishing
www.centro-inc.com
4727 McPherson Avenue
St. Louis, MO 63108
Tel: 314.454.0111
World-class lighting, furniture, and accessory store.

Chiasso
www.chiasso.com
Tel: 877.CHIASSO
Internet and catalogue featuring furniture, decorative accessories, and textiles to complement your modern lifestyle.

Circa 50
www.circa50.com
Tel: 802.362.3796
Online retailer of mid-century design and modern furniture by top manufacturers such as Herman Miller, Knoll, Kartell, and Vitra.

Current, Inc.
www.currentonline.com
629 Western Avenue
Seattle, WA 98104
Tel: 206.622.2433
Timeless modern furniture, lighting, and home accessories.

Dane Décor
www.danedecor.com
315 Arch Street
Philadelphia, PA 19106
Tel: 215.922.2104
An authority on unique, contemporary, and Scandinavian furniture.

Design Addict
www.designaddict.com
Links to over 4,000 modern, post-modern, and contemporary design sites including online magazines, museums, and retailers.

Design Public
www.designpublic.com
Tel: 800.506.6541
Shop online by brand, category, or room for the best design of today.

Design Store
www.designstore.com
Tel: 303.750.3607
The best of contemporary and modern design from A to Z.

Design Within Reach
www.dwr.com
Locations nationwide
Tel: 800.944.2233
Easy access to well-designed furnishings traditionally found only in designer showrooms.

DNA European Design Studio
www.shopdnagallery.net
1990 Columbia Street
San Diego, CA 92101
Tel: 619.235.6882
Furniture and accessories for the home, kitchen, and office.

Ebay
www.ebay.com
Online auctions: A global trading platform where you can find practically anything.

European Living
www.europeanliving.com
15 Ionia Avenue
Grand Rapids, MI 49503
Tel: 616.451.3376
Modern design imports for living, dining, kitchen, bath, and office.

Fitzsu Society
www.fitzsu.com
7970 Melrose Avenue
Los Angeles, CA 90046
Tel: 323.655.1908
Designer home furnishings store with a unique registry service.

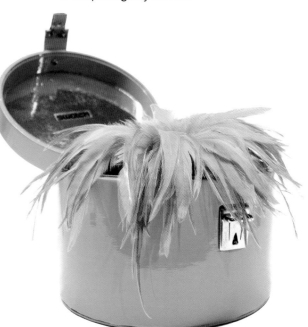

Fosters Urban Homeware

www.shopfosters.com
124 North 3rd Street
Philadelphia, PA 19106
Tel: 267.671.0588
Eat, bathe, work, live, play, sleep in your own style.

Highbrow Furniture

www.highbrowfurniture.com
2110 8th Avenue South
Nashville, TN 37204
Tel: 888.329.0219
Designer classic modern furniture, lighting, and accessories.

Hive Modern

www.hivemodern.com
Tel: 866.MOD.HIVE
Web-stop for the savvy design enthusiast.

iDcollection

www.i-dcollection.com
537 SW 12th Avenue
Portland, OR 97205
Tel: 503.228.8825
An extensive collection of "intelligent design" for the modern taste.

Limn

www.limn.com
290 Townsend Street
San Francisco, CA 94107
Tel: 415.543.5466
A multi-leveled resource for design-driven furniture, lighting, accessories, and art for the home and office.

Luminaire

www.luminaire.com
4040 NE 2nd Avenue
Miami, FL 33127
Tel: 305.576.5788
Creating environments for living, dining, working, sleeping, and dreaming.
Showroom also in Chicago.

MoMA Store

www.momastore.org
11 West 53rd Street
New York, NY 10019
Tel: 212.708.9700
A selection of thoughtfully designed products supported by the Museum of Modern Art.

Moss

www.mossonline.com
146 Greene Street
New York, NY 10012
Tel: 212.204.7100
A full service e-commerce site offering nearly every product available at their New York store. One of the largest resources for modern design products.

The Magazine

www.themagazine.info
1823 Eastshore Highway
Berkeley, CA 94710
Tel: 510.549.2282
The best of modern furniture and product design, from classic design pieces to the latest European products.

Plushpod

www.plushpod.com
8211 West 3rd Street
Los Angeles, CA 90048
Tel: 866.642.5166
Furniture and accessories from new and notable visionary designers.

RetroModern

www.retromodern.com
805 Peachtree Street
Atlanta, GA 30308
Tel: 404.724.0093
A wide selection of contemporary design for the home. An Alessi flagship store.

Sublime American Design

www.sublimeamericandesign.com
26 Varick Street
New York, NY 10013
Tel: 212.941.8888
Home furnishings store in New York City devoted to work by designers who live and work in the United States.

Surrounding

www.surrounding.com
3249 South La Cienega Boulevard
Los Angeles, CA 90016
Tel: 310.342.0402
Lighting, interiors, and accessories from around the world.

Target

www.target.com
Locations nationwide
Tel: 800.440.0680
Bringing good design to the masses.

The Terence Conran Shop

www.conran.com
407 East 59th Street
New York, NY 10022
Tel: 212.755.9079
Classic and contemporary homeware products approved by Terence Conran.

Unica Home

www.unicahome.com
7540 South Industrial Road
Las Vegas, NV 89139
Tel: 888.89.UNICA
Features the largest selection of modern design, furnishings, lighting, and accessories on their easy-to-navigate website.

Voltage

www.voltagefurniture.com
3209 Madison Road
Cincinnati, OH 45209
Tel: 513.871.5483
Furniture, lighting, and accessories to inspire your living spaces.

What to read

Magazines

Abitare
www.abitare.it
Widely distributed monthly magazine on architecture, interiors, and design. Magazine and website are in Italian with English translation available.

Azure
www.azuremagazine.com
This Canadian magazine profiles international designers and architects, reports on major trade fairs in North America and Europe, and investigates design issues related to our changing society.

Domus
www.domusweb.it
Italian magazine with a truly international scope. Covers architecture, interiors, products, and books on design. Magazine and online resources available in English.

Dwell
www.dwellmag.com
Monthly magazine promoting design innovation in architecture, interiors, and products.

Elle Decor
www.elledecor.com
Monthly magazine covering the latest fads in home furnishings and interiors.

House and Garden
www.houseandgarden.com
Great ideas for your living spaces that relate to current trends in home decor.

ICON Magazine
www.icon-magazine.co.uk
This British magazine celebrates the design process and the talented designers behind some of the world's most innovative work.

I.D. Magazine
www.idonline.com
This industrial design magazine covers the art, business, and culture of design. *I.D.* hosts an Annual Design Review and features nearly 200 award winners in its August issue.

InDesign
www.indesign.com.au
Published quarterly, *InDesign* magazine is an international source for the best interior and architectural products.

Interior Design
www.interiordesign.net
Home and office furnishings abound in this monthly magazine featuring designer interior spaces.

Metropolis
www.metropolismag.com
Exploring how deep issues surrounding architecture, interior design, product design, graphic design, crafts, planning, and preservation affect contemporary life.

Metropolitan Home
www.methome.com
Monthly magazine packed with the latest trends and products, as well as the creations of the world's most brilliant designers.

Surface
www.surfacemag.com
Monthly magazine that reports on trend leaders in the fashion, interiors, architecture, graphics, film, and music industries.

Wallpaper
www.wallpaper.com
A monthly magazine for international design, interiors, and lifestyle. *Wallpaper* has an online directory of featured designers, retailers, and manufacturers.

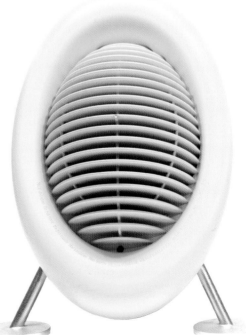

Online Resources

Antiques of the Future Collection
www.antiquesofthefuture.com
A virtual museum showcasing high-designed products, their designers, and their manufacturers.

Cooper-Hewitt, National Design Museum
www.cooperhewitt.org
Smithsonian Institution's Cooper-Hewitt is devoted exclusively to historic and contemporary design. The museum honors American creators and inventors in its annual National Design Awards Program.

Core77
www.core77.com
Reporting and reviewing the latest news and events in the design world. Includes extensive resources for designers.

Design Addict
www.designaddict.com
A leading design portal online for modern and post-modern design lovers. Browse virtual exhibitions and interviews, search an extensive index and links directory, or participate in a discussion forum.

Designboom
www.designboom.com
Find facts, opinions, and who's who in classic and modern design.

Design Museum, London
www.designmuseum.org
Discover more about the designers, architects, and technologies featured at the Design Museum in their online archive of modern and contemporary design. The museum honors a Designer of the Year.

Design Engine.com
www.designengine.com
News, events, designers, products, and links that will familiarize you with the designer world.

GOOD DESIGN Awards
www.chi-athenaeum.org
GOOD DESIGN is the world's oldest and most celebrated awards program, bestowing international recognition on designers and manufacturers. It is organized by the Chicago Athenaeum Museum of Architecture and Design.

GoMod
www.goMod.com
Resource for enthusiasts and collectors of modern design at all levels.

HGTV
www.hgtv.com
Home and Garden Television presents a wide range of programs focusing on the design community.

IDSA
www.idsa.org
The Industrial Designer's Society of America website has design news and a section highlighting their annual IDEA award winners, which are also published in *Business Week* magazine.

iF Award
www.ifdesign.de
Industrie Forum Design Hannover is one of the oldest design centers in Europe. Since its inauguration in 1953, the iF design award has been a prestigious trademark for outstanding design.

The Museum of Modern Art
www.moma.org
The Museum of Modern Art in New York, dedicated to being the foremost museum of modern art in the world, has a prominent design collection.

reddot online
www.red-dot.de
Search online for the winners of the red dot award, an international product design competition. A Design Innovations Yearbook is also printed annually, showcasing the best design of the times.

Share
www.sharedutchdesign.nl
Easy-to-search database of links to Dutch and international design sites, including links to awards sites.

Vivid Centre for Design
www.vividvormgeving.nl
New international directions in industrial design, graphics, art, and architecture, providing extensive background information on designers.

192

Acknowledgments

THIS BOOK WAS CREATED in total collaboration between the writer, photographer, and graphic designer. I would like to thank Kelly Turso, who styled and shot all of the photographs in this book. With her exceptional eye and marvelous flair, she captured the spirit of each object, using clever references, allusion, and humor. And I would like to thank Lisa Benn Costigan, who applied her clean and sophisticated graphic style to every aspect of the book's design, including the cover and logo.

I also benefited from the help of other people: Lea Bogdan, a talented industrial designer who first organized and catalogued the collection; Amy Hibler, who provided invaluable research and structure for the book; Kathryn Hiesinger, the curator of modern and contemporary design at the Philadelphia Museum of Art, who offered a curator's insight on the content; and my husband, David Seltzer, who supplied the humorous observations in the text but still can't tell a teapot from a toilet brush.

And I would like to thank my children, Jamie and Evan, who continue to wait for me to put dinner on the table.